LEADING THE CREATIVE MIND

ANTHONY S. LAKE

LEADING THE CREATIVE MIND

ANTHONY S. LAKE

Common Ground

First published in Champaign, Illinois in 2011
by Common Ground Publishing LLC
as part of The Organization series

Library of Congress Cataloging-in-Publication Data

Lake, Anthony S.
Leading the creative mind / Anthony S. Lake.

 p. cm.

ISBN 978-1-86335-976-4 (pbk : alk. paper) -- ISBN 978-1-86335-977-1 (pdf)
1. Arts--Management. 2. Leadership. I. Title.

NX760.L35 2011
700.68'3--dc23

2011033703

For Dennis

Table of Contents

Foreword .xii

Chapter 1: Airport Books . 1
 Good and Bad . 1

Chapter 2: How Does Leadership Occur? . 11
 Shangri-La Automotive Group .11
 Nirvana Repertory Theater . 16

Chapter 3: Effective and Ineffective Leaders in the Arts 19
 Maturity . 19
 Instrumental Leader . 21
 Charismatic Leader . 22
 Personable Leader . 23
 Inspirational Leader . 24
 Trusting Leader . 25
 Communicative Leader . 26
 Consensus Leader . 26
 Collaborative Leader . 27

Chapter 4: Ineffectiveness .29
 Synergy . 29
 The Fragile Ego . 32
 Communicating and Listening . 33
 Constraint Versus Restraint . 36
 Disorganization . 37
 Casting . 38
 Rehearsal Politics . 39

Chapter 5: Effectiveness .43
 The One Book Principle . 43
 Collaboration as a Means for Growth and Improvement 45
 Respect . 47
 Trust . 50
 Encouraging Creative Thinking . 52
 The Development of Consensus . 56

Chapter 6: Steps in the Creative Process **63**

 Politics ... 63

 Creative Process Steps 68

 A Case Study ... 69

 Identifying the Real Problem 71

 How Is Creativity Different? 73

Chapter 7: The Four Pillars of the Framework **77**

 Carrots and Sticks 77

 Yes and No Men .. 78

 The Four Pillars ... 80

 Keep the Pressure On 80

 Encouragement .. 83

 Containing Anxiety 84

 Lowering Defenses .. 85

Chapter 8: Creative People **89**

 We Are All on Board 89

 What Is an Audience? 90

 Casting .. 91

 Bureaucracy and Organizational Charts 93

 Using Authority .. 95

Chapter 9: Fitting the Pieces Together **97**

 Speaking or Thinking 97

 Gesturing ... 101

 More Actor Training 101

Chapter 10: Exercising Your Creative Leadership Muscles **105**

 Practice Makes Perfect 105

 Reflection and Sensitive Engagement with Others 106

 Designing Work Groups 110

 Develop and Address Problems 111

 Fixing Work Groups 112

Chapter 11: What it All Means **117**

Anthony S. Lake has over two decades of leadership experience in the non-profit sector, focused specifically on the arts, including as Executive Director of a Tony-nominated theater. His career as an arts executive led to an appointment running one of the nation's pre-eminent graduate training programs in arts management, where he researched and wrote criteria for training the next generation of arts leaders. This research agenda led to the discovery that leadership in the arts is not only unique, but is also becoming increasingly applicable to all areas of business as the global economy transitions to a creative, knowledge base. His research (which appears in journals such as The Journal of Arts Management, Law and Society, The International Journal of the Humanities, The International Journal of Business and Social Science, and The International Journal of Arts in Society,) has brought about a number of discussions about leading the creative mind. He holds undergraduate and graduate degrees from California State University in arts management, and is a PhD candidate in Business Administration, with a focus on Organizational Leadership.

As a creative writer, Lake has written for the stage for over two decades and has dozens of scripts produced internationally, including his work on the script for the national tour of *The Christmas Box,* which garnered critical praise over the course of several years. As the author of *The Enchanted Cottage,* he worked with The Motels' singer/songwriter Martha Davis. His collaboration on musical adaptations of *It's a Wonderful Life* and *The Scarlet Letter* won him rave reviews. Two of his plays have been published in The Journal of Creative Work, and most recently, Lake has collaborated on *Mermaids,* penning the script for MGM On Stage. He wrote the screenplay for the independent film *Shadows.* He has also written two novels.

Foreword

Anthony Lake has done a wonderful job of bringing together information on leadership and leadership styles for individuals who work in the administration of creative people. He is one of the first authors who has compared and contrasted leadership styles from businesses with leaders in the arts, in both successful and unsuccessful cases, and the comparisons provide many lessons. The examples of leadership styles brought me back to directors I had served under in all the plays I was involved with during my college years. As the Music Man in *The Teahouse of the August Moon*, my director was the perfect example of the Charismatic Leader that Anthony describes so eloquently. It brought back many fond memories of those experiences.

The best thing about writing these notes was the opportunity to read about leadership from the interesting, diverse, and stimulating vantage point of Anthony's experience from the arts administration and creative sector. It is truly enjoyable for someone like myself who likes to have good conversation at the local coffee shop, to be able to have a conversation like this about an area I usually don't spend a lot of time thinking about -- but it is still related to a topic not forgotten. My only regret is that I could not have these conversations in more of an interactive fashion with the kind of students that Anthony works with on a regular basis. I am certain I would have learned a lot!

Getting through this book, unbelievably, is like a "rite of passage." Another professor wrote the story below, and it seems worth sharing in here:

"Have you ever heard the legend of the Cherokee Indian youth's rite of passage? His father takes him into the forest, blindfolds him and leaves him alone. He is required to sit on a stump the whole night and not to remove the blindfold until the rays of the morning sun shine through it. He cannot cry out for help to anyone. Once he survives the night, he is a MAN and he is considered a leader of his tribe. He cannot tell the other boys of this experience, because each lad must come into manhood on his own. The boy is naturally terrified. He can hear all kinds of noises. Wild beasts must surely be all around him. Maybe even some human might do him harm.

The wind blew the grass and earth, and shook his stump, but he sat stoically, never removing the blindfold. It would be the only way he could become a man and the only way he could become a leader of his tribe! Finally, after a horrific night the sun appeared and he removed his blindfold. It was then that he discovered his father sitting on the stump next to him. He had been there at watch the entire night, protecting his son from harm."

There is no doubt that leadership does come from within and can be improved upon by our knowledge and experience. However, having a good mentor, a helpful guide, a good teacher, and sometimes just someone to listen to us can make all the difference in the world. The most challenging thing for effective leaders is not always what they are required to do but how

they handle themselves when they under stress. They are challenged when they lack sleep, when they have to deal with real nasty problems and ask staff members to leave, and when morale is down and they need to inspire everyone to get motivated again and come back tomorrow for a better performance. The director or leader has to be like the Cherokee father who is there at watch the entire night, protecting his or her child, his cast or crew, or him employees from harm.

As directors or actors, we, too, should never feel alone. Even when we don't know it, the empty theater or office is full of all the actors and actresses or employees) who came before us, who put on their great performances or did their work in this same hallowed space. Even if you don't believe in God, as you sit there you can't help but feel that these same spirits are all there watching over you -- sitting on the stump beside you. When trouble comes, all you have to do is draw strength from their presence.

Moral of the story: Just because you cannot see something or someone, it does not mean they are not there. Throughout the history of theater, all the great directors became effective leaders because they were persistent and determined to get the job done, worked hard, learned from their mistakes, knew how to lead and how to follow, learned how to listen to others, worked well with others, avoided costly mistakes, and achieved their goals and objectives.

This book should be required reading for anyone in business who is directing others or wondering if they will ever have the opportunity to do so in the future.

<div align="right">Ken Gossett</div>

Dr. Ken Gossett has over forty years of administrative experience in public and private programs and is the coauthor of Quality Assurance for Long Term Care Providers (Sage, 1990).

Chapter 1
Airport Books

"The worth of a book is to be measured by what you can carry away from it."

- James Bryce

Good and Bad

Why a book about leading the creative mind? Isn't leadership always the same, regardless of the people being led and how they think? It certainly should be. However, as our world embraces the global nature of the twenty-first-century economy, as we outsource mechanical function, as our communication methods advance to a point where face-to-face contact loses its import, we find ourselves staring at a very different workplace—one where we no longer simply coordinate human capital and material goods. Now we face the challenges that occurred at the beginning of the last century. We must innovate. And in order to innovate effectively, we have to become smarter about how we lead creative people.[1] We have to become much smarter about "doing more with less" and "working smarter not just harder."

Good leadership is different from bad leadership. It is a simple axiom. We know it to be true. "Good" is different from "bad." However, those are extremes, and leadership occurs on a long continuum. Some people are good

at exercising leadership in certain situations, but cannot replicate it in other situations. Some people are called "leaders" when they are really glorified managers.[2] Others are never considered leaders, though they exercise the process of leadership skillfully and regularly.[3]

Leadership is, essentially, the same thing regardless of the discipline in which it is exercised, but in the collaborative arts, the exercise of leadership has occurred in a very clear and specific way for a long time. That this tradition may also be used as a touchstone is what makes this book unique.

Management theorists weren't talking about leadership as some sort of offshoot of management until just a few decades ago,[4] and even then, some of the greatest thinkers in the academic study of management refused to accept that leadership was anything different than basic management. "Management," broadly defined, is the function of coordinating resources, both human and financial. We have studied it closely since the industrial revolution. But management as a function has been around as long as man has been around.[5]

When you paint with broad strokes, you can cover the canvas quickly, but the nuance of detail is lost. So, too, is the nuance of detail lost in such broad definitions of management. Yes, management is about coordinating money and effort to complete work efficiently and effectively. We all know the difference between management and staff. Management receives greater compensation for telling staff what to do. But over the last few decades we have also started to hear about leadership.

Everyone wants to be a leader. Every company needs a leader. The leader is the "visionary." The leader is the rudder of the ship; the leader sets the tone, sets the course, and sets the example. In short, we have come to define the leader as the manager who is most in charge, the one who sees the future and shares her prophecies with the underlings so they can blindly follow her light into a promising next generation of business.

Well, that is a load of bunk, and you surely figured that out as you saw it unfolding. Leaders are not oracles or mystics, nor do they have some superhuman ability to lead.

Most of us do not know anyone in a position of leadership who has visions. I am guessing that neither do you. I am being a little facetious, of course. I know that when we talk about a "vision" for a company, we are really talking about dreams for the future, or ideas that are pre-implementation. So a leader is someone who dreams big and has great ideas. Well, maybe and maybe not. Thomas Edison did have a great idea with the light bulb. He knew the end product would be great. Did that make him a leader? Probably not. But Edison set about trying to make a light bulb, and after about a thousand failures, he had a success. Edison led the way in illumination technology. But was he a leader of men (and women)?

We are often mired in the latest catchphrase about leadership, and the word "vision" stuck a long time ago. A company must have a vision for a brighter future or it will disappear with the Edsel and the Commodore computer and TWA. Certainly, we cannot say that those companies failed, along with countless others just because their crystal balls got too cloudy to

help them define the future and then go after it. The whole "vision" of the future cliché is an elusive paradigm, far more so than countless leadership gurus would have you think.

If you go to any online bookstore and search their books for the word "leadership," you are likely to get a lot of hits. Recently, Amazon.com produced 263,510 results for the term. That is a lot of writing on leadership; indeed, it seems to be a ridiculous amount considering that we only really started talking about leadership relatively recently in the grand scheme of things. Even in the field of management, the study of the uniqueness of leadership is relatively new. Why so many books?

Maybe everyone has a different theory about how to develop a "vision," and these books each set about to instruct the reader on how to do that. At first glance, it turns out that precious few books (if any) tell you how to develop a vision. Sure, they all have four strategies and eight tactics for exercising great leadership. They make it appear so simple. Good leadership is clearly just a matter of breaking down into little parts one's consensus-building capacity, or teamwork skills, or sense of urgency, or ability to have "vision," and then of rebuilding those parts using "five easy steps" (or whatever the author's particular number may be).

CEOs pick up the latest tome in the Phoenix airport, and after they have finished their business on the computer in the airport lounge, they settle in to read about the latest leadership fix. By the time they set foot in Washington, they are ready to send emails to the upper management team about how the book has strategies that will change their company, how they should all read it, and how the company should hire the author to speak at its next retreat.

The retreat, of course, will be held in a hotel in some "escape-like" place only a few hours from home (and only seconds from the office via the pervasive Internet connections), but the mahogany-lined walls and walnut floors, rich colored rugs and thick cushy beds will regularly remind the management team that they are there for important business. When the latest leadership author begins to regurgitate his philosophies on the topic, all will listen with great interest. At the breaks, they will bubble with insight and begin to see how putting into practice tactic two will quickly change the way the entire marketing department works. Product development will really want to focus on tactic four. Overall, the company from top to bottom could use a paint job from the whole kit-and-caboodle of this great writer/researcher/theoretician's idea.

They will leave the retreat invigorated by this man who has such vision for companies of the future. What is amazing about this is that writers on the subject of leadership cover the subject by observing the past. They do not look to the future at all. They look for patterns in what is currently happening and try to point them out. No one says, "This is how leadership is going to work in the future." No one has the guts, or the vision, to say *that*.

Since "visioning" is such an integral part of leadership—we know this from the observations of countless gurus—there should be much written about how to go about having a vision, or creating a vision, or developing a

vision. But, as it turns out, there is very little written about how to develop a "vision" at all. Even the book *Leadership Can Be Taught* doesn't teach you how to develop a vision. Instead, it takes you through the processes of a class taught at Harvard on leadership.[6]

So does that class at Harvard teach you how to have a vision? Does it teach you how to "set a tone, be a rudder, set an example"? Of course not. All it does is teach you how to analyze things, and how to treat other people the way a leader *should* treat other people.

It does not tell you that you have to be nice. It does not tell you that you have to be heavy-handed (or even that there are only some appropriate times to be heavy-handed). In fact, it does not shape you into any mold of a leader, which is a good thing. Imagine there was a course that could fit everyone into the perfect leader "mold." Everything would be the same. Everyone would act the same. We would all aspire to be and do the same things. We would all have the same visions. That is not very visionary.

I don't know about you, but there is no crystal ball hidden in my desk. I do not have one at home. There is no oracle in my study. There is no medium living next door, and my Ouija Board is not even particularly good at predicting the future with only yes and no questions. At times, I have been called a leader, and yet I do not seem to have any visions. None.

I take even less credit for my successes in the theater, because I do not claim to have any great artistic abilities. I have directed everything from huge operettas to small family plays and all sorts of things that might fit in between. In almost every case, I was asked to present my "vision" for the play, and in every case, I was never quite sure what my "vision" was. Sure, I could say how I thought things would look and sound on opening night, but that was not some mystical vision. It was just an idea of how best to avoid looking like an idiot when an audience was watching. I have seen good plays and bad plays, and I pretty much know the difference (don't we all?). My vision for something I am directing is that it will end up being the former.

I never tell a set designer what the scenery should look like. I would never draw up the costumes for the costume designer. I cannot tell actors how to say their lines. These people all have developed skills to do their jobs, and they are better at them than I would be. No, my job is not really to direct them at all, for directing suggests that I point them in the direction they should be going. My job is about leading them somewhere together, in a collaborative fashion. I do it not by having a "vision" for the play, as so many directors feel compelled to do (it is, after all, what they are taught in directing school). What I do is coordinate the leadership process.

I have been called a heretic for suggesting that leadership is not just the work of the visionary-as-leader.[7] Yes, those people exist. We all know the stories, have read the cases, and understand the special features. One book tells us that we are born to be great.[8] Another says brilliant leaders develop their brilliant skills through a process;[9] some are softies and some are bullies; some did great things and failed at other ventures. This book is not so interested in those people. If you are one of them, put it down; you need no one else. This book is about everyone else in the leadership process.

I have had some opportunities to be in the middle of that leadership process. I call it a process, because when I read all those things about greatness and leaders and tactics and strategies, about how to "implement change" in a company, and how to shape the future, I can never see myself. Sure, I feel inspired by the words like everyone else, but I never see myself. I have had my share of leadership successes, as small and insignificant as they may be. My background is not only in directing. On several occasions, I have handled the non-artistic management of theaters as well. I have run huge not-for-profit theaters; I have consulted for gigantic for-profit theaters. I have worked with tiny theater companies unsure of where they were headed (and who thought I would have a vision for them) and I have worked on arts policy. I teach arts management and I study arts leaders.

All of those hats have given me a good insight into what goes on in a theater company, but teaching arts management has forced me to try to find the differences between MBA management and MFA (Master of Fine Arts) management. That is, why would I teach management leading to a degree in fine arts as opposed to one in business administration? It confused me for a long time, because the distinction is unclear. Management is management is management, right? And leadership is leadership is leadership. There may be different tactics for different people, but really, it is all the same, is it not?

In the process of trying to learn and understand the similarities between the two, however, I came across a number of distinctions. What I did was set about to become the best academician possible on leadership. I read plenty of those airport books, I studied the research, I bored myself silly with every psychological theory I could dig up that addressed leadership. I followed communication models down one path. I followed sociology models down another. I talked to leaders, both self-proclaimed and anointed, and I asked them what made them tick—I often met them in those airport lounges and recognized them by the book they were reading.

As I studied leadership from a management perspective, all the while keeping in mind that I was also teaching it from an arts perspective, I found myself regularly reminded that I had students who were supposed to be gaining something from me. In theater, as in all the arts, learning the craft occurs through practice. The easiest example of this is the pianist. The best of pianists, the world's greatest, still practice the very first thing they were taught to practice: scales. They know the scales, of course. They never intend to show them off in public. They will never present a concert of scales. But daily, they practice those scales. They first did it because someone told them it would help them improve. As they improved, concert pianists will tell you, they began to "feel" the scales in their fingers. Their hands develop a connection to the keys when they run through the scales. Each day that they practice their scales, the connection grows a tiny bit more. The practice of something they "appear" to have mastered will never end, because as they get better and better at it, they become more and more aware that there is no such thing as perfection. It is all about the journey.

My students needed something to practice.

I was supposed to be teaching them leadership. How do you practice leadership?

I mentioned that in all those leadership books that I have read on cross-country flights, and even in my spare time at home, I have never been able to see myself. Maybe that is because I am not a leader and I am incapable of being a leader. I am certainly never going to be a captain of industry. I think I probably could do it, but I would be miserable. Those books all speak as if they are talking to captains of industry, though we "little people" might glean something important from them. I have asked around. You should try it. People who read these books do not see themselves in there, either (unless their story happens to be one of the cases mentioned).

I suppose I could have been faking it when I was leading those companies. It is possible that I just had everyone fooled, and I was wise enough to bail out before someone figured out that I was a fraud, not gifted with the requisite "visionary" powers. But that seems unlikely. I know I never woke up with visions, yet people said I was visionary. I know that I never thought of myself as Moses leading his people to the Promised Land. I just plugged away and did what I thought was right. I educated myself as much as I possibly could. I studied what went on, both in product development and in the marketplace. I listened to the consumer. I gathered my data and conducted my research. I sat with my staff and discussed it. We had strategy sessions and occasionally hired an expert to give us guidance. There were many stressful days, usually when I was unsure about what I was doing but I had to do it anyway. There were times when I was sure the best thing for a company was to get someone who really knew how to be a leader, because I was not the person in those books. I was just an ordinary man. Every time I started to believe company successes might have something to do with me, I reminded myself that I did not have visions. So how good could I really be? I would have to have visions if I was really a successful leader, wouldn't I?

Looking back, I now realize that what seems more likely is that I did not have to have any visions at all to be successful in the practice of leadership.

Not one.

The practice of leadership is what that class at Harvard attempts to teach, and not surprisingly, its creator, Ronald Heifetz, has a background in the arts, specifically music. He does not shy away from this background. He does not apologize for the influence the arts have brought to his thinking. He embraces it in his work and in his study and in his class. To Professor Heifetz, music requires some very important habits which apply equally well to leadership. Two of those are of primary importance: listening and the aforementioned practicing.[3]

In a musical endeavor, you have to listen, and listen intently, to the sounds of the instrument or voice. You have to make adjustments based on what you hear, which allows for improvement. When you finally have all the sounds exactly the way you want them, you use them to elicit some sort of response from the listener. You have used your listening skills to hone a final product that can change another person.[10]

You did it through practice. You tried one way of playing or singing a note and did not like it, so you tried another. You made mistakes with certain notes, and you tried again until, upon repetition, you could make the note always sound the way you intended. For good measure, you practiced things like scales and arpeggios. You practiced them because they are some basic rules of music, rules that have no specific correlation to the music you wanted to make to have an impact on your listener, but rules that would help you improve your technique so you could be more efficient at playing the music the next time.

In the practice of leadership, you have to listen as well. You have to listen to everyone. You have multiple constituencies to whom you must listen. There is your staff, the market, your competition, your family, the neighbors, and your board of directors, the shareholders, Wall Street, regulators, and on and on. They all have something to say, and you cannot ignore them. If you do, you are bound to fail. And it is a cacophony. It is overwhelming. Real leaders, the ones in all those books, must also have magical abilities which allow them to hear and process all of this information, and that is how they develop their visions. As for mortals like you and me, we listen one piece at a time, and we always feel that we are way behind in hearing everything that we should, but we just keep plugging away at it. I remind everyone who works with me that they need to listen, as well.

The world of business is littered with stories of some incredibly talented and even more incredibly well-paid CEOs, who were brought on to lead some huge corporation. They stepped into their role, assessed the situation, and made some changes. The company did brilliantly, and their pay was increased to some vastly ridiculous amount. Then the company started to falter. The CEO with all the insight, who was able to lead the corporation into its glory days, was hardly able to weather some little managerial bump. Without much fanfare, and little more than a few millions dollars in severance, he is shown the exit.

You are probably thinking about the story you read a week or two ago in the business section. "This very thing happened just recently to someone." That is because it happens all the time. People who excel at leadership in one situation continually fail in other situations. More often than not, when they come in as an outsider, they succeed, but once they have assimilated into a business and become an insider, they simply cannot keep their leadership light burning bright. Maybe the visions simply stop. The next step in the process is that this leadership expert will write a book about leadership, and you can learn their secrets. The ticker at Amazon.com just went up to 263,511.

In reality, it is not so complex a situation to understand. When they come in fresh to a company, and they start listening to all these people they are just meeting, they pick up words, phrases, ideas, thoughts, plans, hopes, dreams, ideas, concerns, complaints, and cues about where the company needs to go. They put all those things they have heard into an assessment of where the company is and where it needs to go. They develop a plan, they share the plan with all the people who said all those things, and they put the

plan into action. Voilà. The company gets to where it needs to go. When the company gets there, the people who had voiced all of those thoughts are no longer voicing them. Why would they? The company has arrived. Eventually, however, things start to go a little south, and no one is sure why or how to deal with it, and finally, the leader gets his severance.

The wisest of leaders knows that when they get a company where they think it needs to go, they should step aside and let a new leader take the reins. For a new leader will likely see the next direction the company should head. The new leader will have a new vision. People are different, leaders are different, and maybe to be successful as a leader you have to be the right person in the right place at the right time.

There is certainly some truth to that. You, however, are not reading this book because you want to be told that being a good leader is all about dumb luck. Nor do you want to read that once you have successfully achieved that pinnacle known as "good leadership," you must step aside before you fail in your next task. You are reading this book because there are creative people who work for you, and you are not quite sure how to lead them. Maybe you don't "get" them. Maybe you "get" them but you don't know how to corral thcm in one direction or another without having them feel trapped inside "the box." In addition, you have probably gotten far enough into this book to realize that the little tidbits and insights, tactics, and suggestions to follow have their basis in the arts, and particularly in theater. Theater artists have never been inside "the box," yet they have been led for centuries. There have been theater leaders since the ancient Greeks started doing theater. There were probably theater directors among the cave dwellers. We just have not found the ancient stone director's chairs yet.

Maybe you realized when you saw the title of this book that famous directors of plays and films, famous conductors, and the like seem to be able to hold onto their status of greatness better than most captains of industry. Maybe you thought, "How is it that artists can have hit after hit, again and again, and business leaders seem to hit and miss a lot more?" Well, there is a reason, and it is simple. In the collaborative arts, leaders have had to conduct true leadership, out in the open, without faltering, for centuries. Directors and conductors do not (or at least did not until very recently) have to concern themselves with financial reports and business statements, strategic plans and operational issues. They simply have to lead their constituencies. They do so with a collaborative effort performance after performance, night after night. In theater, which is a collaborative art form, there is no way to function other than collaboratively. They build strong teams. They have to. The great leaders know how to work toward consensus. It is because we allow them to conduct leadership without also being managers, that these people make excellent case studies.

"Collaboration is key. Each and every time I have worked with a fantastic leader in theater, one word comes to mind: collaboration. One instance in which a director was an extraordinarily good leader was in a production that I felt that each person involved had a valid say in decisions.

"Was this production a democracy? No. The director was still the leader of the 'dictatorship' that a production should be. By that, I mean that the director was in charge of the concept or the 'vision' and made sure that we were all working towards the common goal. This director was willing to try new things and gave credit where credit was due. Not always did the new thing make it into the production, but sometimes just by trying something new, one can figure out what the production is not. It is as if by defining what a production is not, the company as a whole has a better understanding of exactly what the production is.

"This director gave the members of the company the freedom to explore these options, but also had the understanding that it was his responsibility to unify the company to create a cohesive production. This director was extremely knowledgeable and extremely willing to share this knowledge to better the production. He knew when to listen and when to speak. He made his cast feel an ownership to the production and a sense of pride in the art they were creating, by collaborating together as a cohesive company."

–Steve, Texas[1]

One of the things that class at Harvard teaches is that you have to keep listening. When there is nothing to hear, you cannot just sit back and collect your stock options. Instead, you turn up the heat on the people who used to have things to say, and find out what it is they are not saying any more.

You see, all those people, all those constituencies, they are the ones who have the vision. The leader does not pull ideas from a crystal ball or from anywhere else. What the leader does is listen to what everyone has to say, weighs those thoughts, evaluates them, interprets them, and puts them together in a manner that will lead to a positive outcome. The vision actually does not come from the leader at all. It comes from everyone else. Sure, sometimes a leader comes in and says, "Here's a new way we're going to lead," without listening to a single person. Sometimes that works just fine. However, even in those situations, the leader had enough information to know that the company needed a new direction, simply to get it out of a rut. I can guarantee you that such edicts do not happen as often as you think, and with the same leader in the same company, they do not happen more than once.

The good leaders come into a company and listen. We have determined this much. Why don't they survive? Well, frankly, they do not have practice at leading. They know how to hear what is being said, but they have not practiced getting people to say the things that are not being said. It is this practice that is required to perfect the skills of leadership.

1. In most cases, interviewees have requested anonymity, so names and locations have been changed.

1. Pink, D.H., *A Whole New Mind: Moving From the Information Age to the Conceptual Age.* 2005, New York: Riverhead Books.
2. Buckingham, M., *The One Thing you Need to Know: About Great Managing, Great Leading, and Sustained Individual Success.* 2005, New York: Free Press.
3. Heifetz, R.A., *Leadership Without Easy Answers.* 1994, Cambridge, Mass.: Belknap Press of Harvard University Press.
4. Burns, J.M., *Leadership.* 1st ed. 1978, New York: Harper & Row.
5. Drucker, P.F., *The New Realities: In Government and Politics, in Economics and Business, in Society and World View.* 1st ed. 1989, New York: Harper & Row.
6. Parks, S.D., *Leadership Can Be Taught: A Bold Approach for a Complex World.* 2005, Boston, Mass.: Harvard Business School Press.
7. Nanus, B., *Visionary Leadership: Creating a Compelling Sense of Direction for Your Organization.* 1992, San Francisco, CA: Jossey-Bass.
8. Landrum, G.N., *Eight Keys to Greatness: How to Unlock your Hidden Potential.* 1999, Amherst, NY: Prometheus Books.
9. Covey, S.R., *The 8th Habit: From Effectiveness to Greatness.* 2004, New York, NY: Free Press.
10. Mathieu, W.A., *The Listening Book.* 1991, Boston, MA: Shambhala.

Chapter 2
How Does Leadership Occur?

"The task of the leader is to get his people from where they are to where they have not been."

- Henry Kissinger

Shangri-La Automotive Group

At Shangri-La Automotive, Steven Winston is the CEO. He is an amiable guy. He smiles an awful lot, especially when he is meeting people, and he smiles because he genuinely likes the people he meets. He enjoys interacting with others. Since his teeth are perfect, and he has two dimples on his rugged cheeks, people who meet him seem to like this sandy-blond man as well. He shakes hands firmly and repeats the name of the person he is meeting. However, none of it comes off as the "tricks" of socializing. No, Steve is the real deal.

Shangri-La Auto is not a real business. (You have probably guessed that I made the name up.) However, I am describing a real CEO here. I did not use real names in any of these stories; in fact, the businesses that the people in these stories work for are in different industries altogether than the ones in which I put them. None of that makes much difference. What is

important is that these people allow us to observe different leadership styles, and to see where practicing new leadership techniques might help them be even better leaders.

Shangri-La Auto has thrived for many years. It began as a small consulting firm in Detroit with a leader who knew there was a market for a company that focused on improving automotive interior design for passenger comfort. This man, Marcus Martelli, loved cars, and he was so passionate about making them incredibly comfortable that he was able to infect others with his almost boyish excitement about them. He scoured the country for engineers to come and join the company, and they committed to him for a couple of years in exchange for a meager salary and a promise of lots of opportunities to interact with the top design folks from the Big Three. It was the perfect combination. This man's energy was vibrant, as well as his vision of an ever-growing automotive engineering firm with an expanding customer base, always-growing facilities, and bold designs. The business never quite reached the pinnacle Martelli envisioned, but the company grew rapidly.

Martelli's passion brought investors to the table to construct a new design building, to raise money, and to contract with all the major players. His passion energized the staff and convinced them that following Martelli was the best path. Martelli solved problems. He had great respect from the board, and they would accept whatever he said on face value. He could not only get their buy-in, but he could also get their money and their time simply by asking.

Over the years, Shangri-La Automotive grew into a powerhouse in the design scene in Detroit. Customers flocked each year to have their latest design studied, modeled, and improved upon by Shangri-La. Smaller firms with an eye for passenger comfort began to emerge in the area, trying to capitalize on the success that Martelli was having. In addition, there seemed to be no end to the stream of customers. Every new model of vehicle being explored in Detroit was looking for an expert to help them get it just right. They continued to sign contracts at Shangri-La Auto, and the new competitors did so as well. In fact, Martelli was responsible for changing the automotive consulting scene in Detroit. It's no wonder that the Big Three grew so big, so fast. Martelli certainly served as inspiration, if nothing else.

Eventually, Martelli retired and was replaced with a new CEO. Arthur Fine was hired because he had his own vision for the company. He was not going to simply try to replace Marcus Martelli. Everyone in the selection process knew that replacing Martelli was impossible, so the company required someone with a new vision. It needed someone who could inspire them to go in a new and different direction. It needed someone who could build upon what they had all already achieved. Martelli had always wanted them to reach for the stars, and they knew that they needed someone who saw new and different stars for them to reach toward.

Arthur Fine did, indeed, have a new and different vision for the company. Shangri-La Auto was to no longer focus on passenger comfort, but on vehicle performance. In addition, Fine was going to be the lead engineer on all projects, because his expertise was in vehicle performance. Of course,

Fine did not announce this vision all at once. He knew that would frighten the staff, the board, and the marketplace. And he did not want to do that. He had been promised the world when he came on board. He had been assured that he would have the support he needed to make "his" vision a success. All those constituents knew that their undying support was what made Martelli's vision so great, and they had to pledge the same to Fine.

Fine did, eventually, share his vision with everyone. He explained it in detail, one little piece at a time, being careful not to suddenly surprise everyone with a major shift. He was as passionate about his new vision as his predecessor had been about the last vision. He could see that these new Arthur Fine contracts would really put Shangri-La Auto on the map, not just in Detroit or Michigan, but also on the national stage. He was going to share his gift with the world, and the staff, the board, and the market for Shangri-La Auto were going to get to go along for the ride.

The staff did participate in the process. The board did what they could. The customers continued to sign contracts. Moreover, Fine continued to exercise his great passion for improving vehicle performance. However, after the first contract was fulfilled, although the performance of the vehicle was a little improved, no one saw the great results they expected. The contract came and the contract went. Nothing changed. In fact, except for the fact that they had done an Arthur Fine contract (which no one else was really passionate about) everything else was stationary. No international press took notice. No foreign manufacturers inquired. It was business as usual. It was just different business as usual. Therefore, the hallway chatter started to focus on what this vision was really going to do for the company. After all, Martelli had always just advocated bigger and better, and they were always getting bigger and better. Now Fine was advocating greatness through Arthur Fine's expertise, and they were doing Arthur Fine's thing, but they were not achieving greatness.

It did not take long for the staff and the board and the market to come to the conclusion that Arthur Fine's vision was not right for them. Fine was happy to leave. This group of people was never going to be willing to try something new, experience change, or be willing to go to the next level. At least that is what Arthur Fine thought.

Two great men had now run this company. The energetic, passionate, slight Italian Marcus Martelli, who could run a mile a minute and keep everyone energized, and the slower, more methodical, very confident Arthur Fine.

At this point in its history, Shangri-La Auto decided that maybe finding a suitable Marcus Martelli replacement meant finding someone who understood how Shangri-La Auto really worked. This meant trying to find someone who could be like Martelli without being Martelli. Therefore, they chose one of their staff members who had been with the company since Martelli had founded it.

This new CEO kept things running smoothly. Operationally, things stayed just the way they had been. The company didn't grow, and it seemed to have lost its spark for getting bigger and better, but that was okay. Every-

one was okay. There was no new vision. There was no new direction, and everyone was happy just returning to business as usual, even if it wasn't as "usual" as all that. Guess what? This leader did not last very long, either. Everyone discovered that they needed to change and grow and that they couldn't just stay stuck in the mold Martelli had left them in; they needed to be very particular about finding someone who was young and energetic, and who could help define a vision that wasn't driven by the ego of the leader.

Martelli had such a unique passion, and such an intense pace, that he was irreplaceable. However, Arthur Fine was too methodical about the way he saw the world of cars. He swung the pendulum way too far in the other direction. The insider replacement swung the pendulum back, but not far enough to be able to pick up the reins the way Martelli had handled them. This company needed an outsider's perspective, capable of bringing new vision, clear direction, ample pace, steadfast determination to move toward success, and a love for the work.

So Shangri-La Auto hired John Precinski. He fit the bill perfectly. In addition, he understood exactly what his charge was. This was an automotive engineering company that was losing market share. Its pool of great engineers was smaller than ever, the budgets were shrinking, and it had no direction. It had been trying too hard to follow in the footsteps of Martelli, who had now been gone several years. It was also trying to recover from the strange shifts in operation Fine had made. Precinski was told that he was being brought in to develop a new vision, to help give the company a more rigid structure (so it could achieve that vision) and to set the ship right. Precinski thought he was up to the task, and so did the staff, the board, and the market.

He might have been. Precinski started holding discussions about what might be the best way to move forward. He explored opinions and listened to what people had to say. He gathered all the information that he needed, and then he announced the new vision. There were complaints, so he told those who complained that they could leave if they could not get on board. This generated more complaints, and to those Precinski gave more rigid orders. As the dissention got louder, Precinski's response became swifter and more boisterous. His charge was to do a job, and this company needed his help badly. He was not going to let them whimper and run Shangri-La Auto into anonymity.

Of course, the problem, as Precinski saw it, was that when he wanted the group to come to a consensus, they refused. In fact, they simply grumbled about how things used to be. Therefore, as he gathered information, he had to form it into a vision on his own.

The board, hearing complaints from the staff, felt it easier to support no one.

Eventually, Precinski started firing people, the staff revolted, and Precinski was replaced.

The pendulum was swinging back and forth with these CEOs. First there was Martelli, whom they replaced with an outsider, whom they replaced with an insider, whom they replaced with an outsider. And when Precin-

ski was replaced, they looked inside again. However, this time, they found someone who had spent some time outside as well. He seemed to know the insider problems and the outsider solutions. Above all, he could quiet the terrible dissention that existed among the very fractious staff. So the lanky Steve Winston, he of the genuine smile, stepped up to the plate.

Steve Winston was a conciliator. The staff had been at odds with each other and with Precinski, whose precise, almost meticulous attention to following the appropriate process of what he saw as leadership nearly tore the company apart. Precinski knew he should listen to opinions, develop a vision, and drive it. What he failed to do was really listen. He let people speak their minds, and then, when they had gone on long enough, he told them how things would be. Sometimes the louder staff members could influence him, sometimes not. But what was clear was that while Martelli was passionate, and Fine was self-confident, Precinski was precise. Though no one is really ever that precise.

Steve Winston was only capable of quieting the discomfort. He never had the focus to develop the vision that the company needed. But at the point where he took charge, there seemed to be a genuine interest in getting things back to business as usual. Unfortunately, Winston tried to do so by watching the company sink a little more every year, and waiting to see if the world would change so that business as usual would eventually become something different by comparison. The world, of course, does change, but companies that appear to stand still never look unusual. They look obsolete.

There are two maxims that I like to repeat regularly to my students. The first is that a company is never really standing still. From year to year, it is either growing or shrinking. Can you imagine a company with the exact same number of customers from one year to the next? With the exact same expenses or income? Even for a small company, being stationary is virtually impossible. Yes, there are accounting tricks that make it look like a company is growing when, in fact, things are not improving, but those have nothing to do with a company moving forward.

Some companies move forward because their business propels them, but more often, companies move forward because someone sees where forward is. They will not stop until the company takes one step after another into the unknown, because, after careful consideration, the unknown is better than stagnation. Moreover, if in business there is no standing still, then if you are not moving forward, you are moving backward.

The second maxim I tell my students is actually a quote attributed to General Eric Shinseki: "If you don't like change, you're going to like irrelevance even less." There is nothing magical about it. There is nothing mystical. There is not even anything that wise. It is common sense. Change or die. It is how the world works. Not a day goes by that we, as humans, do not each change a tiny bit. When that ceases, it is because life has ceased. We can fight it all we want, but there is no denying that we will change. Business is the same. It *must* change.

Steve Winston, when he took on the role of CEO of Shangri-La Automotive, was in for a tenure that would get more and more difficult. Because as much as he tried to keep the dissenters quiet, to calm the waters, to smooth over the disruptions, and to keep the company headed in the direction it used to be headed, the thing he was doing was avoiding change. The more he avoided it, the more irrelevant the company became.

Nirvana Repertory Theater

Also in Detroit, about the time that Marcus Martelli was starting up Shangri-La Automotive Group, Brian Artsman was starting up a repertory theater that devoted itself to performing classic theater. Brian loved Shakespeare, and the great American playwrights, and the great European playwrights, and the ancient Greeks, and every other classic play that had endured the test of time. He could watch them all day, every day, if they were being performed that much. He was fascinated by their lessons. He was enthralled by every new interpretation. He believed that they had lasted because they were timeless in their relevance to how society lives and learns and functions.

Artsman directed most of the early productions and all were quite well received. As time went on, he shared the directing duties, but he was always careful to ensure that the directors he hired were people he knew, and knew well. Occasionally he would hear small complaints about the fact that in order to direct at Nirvana, someone had to be in the "in" crowd, and while there was some truth to that, Artsman let the complaints fall like water off a duck's back. He knew it was important to have directors who shared his passion for the classics.

One thing Artsman never seemed to concern himself with was the marketplace. He had marketing people on his staff, and they did their job, but Brian's primary focus was on the product—the plays. He met with the marketing people, and together they would decide which plays to do and when, but then Artsman made the plays and let the marketing people do the marketing.

In fact, that was how Artsman operated in every aspect of Nirvana Rep. He surrounded himself with good people, and then he let them do their own thing. He did not seem to lead at all. He just sort of let people do what they wanted. If someone asked his opinion, he was always willing to give it, but he never interjected it into anything.

"Which color scheme do you like better?" a scenic designer asked him.

"I prefer the blue one, because the mood of the play is very cool," Artsman said.

"That's what I thought, too, but then," responded the scenic designer, "I thought, isn't it an interesting juxtaposition to go with the red, which represents the fire in the main character's belly?"

"Yes," said Artsman. "That is really interesting. I still prefer the blue, but it sounds like you prefer the red."

"I do."

"Then you should go with it."

This was a regular occurrence at Nirvana Rep. Artsman would let everyone go with whatever decision he or she wanted to make.

Oddly, the directors that Artsman hired would work in a very similar fashion. No one ever came in and told actors how they should do something. No directors ever, well, "directed." They always seemed to be there to make sure no one bumped into each other. They guided, sure, but no one ever said, "My vision for this play is that..."

Nirvana Rep grew.

Eventually, Artsman retired, and the new CEO, Everett Galveston, who had directed at Nirvana twice before, picked up the reins. He was passionate about the classics, and he loved to produce them, but he also liked reading modern plays. For two years, he frequently mentioned his love for *producing* the classics along with the fact that he really enjoyed *reading* the modern plays. He would share extremely exciting modern scripts with anyone who would take one. Then he would plead for their opinion. Some hated a script. Some loved a script. Some scripts everyone loved. Some only Galveston loved. However, people were beginning to expect that they were going to be challenged somehow by Galveston's next modern script.

Then at one staff meeting, someone said, "Everett, have you ever considered producing a 'modern' play on our stage?"

The room got suddenly quiet, and everyone looked at Galveston.

"Well, I wonder what the marketing people would think about that idea."

"It's a great idea," said the director of marketing. "We could get a lot of mileage out of it."

The room erupted into pleas for Galveston to please consider producing a modern play in the repertory. Galveston promised to consider it, and asked if anyone would be willing to study how it would affect things like budget, casting, sets, costumes, lights, the marketplace, the board of directors, etc. Within a few minutes, everyone had taken on some task to study the idea.

You can guess where this went. At the next meeting, an enthusiastic staff reported on all the incredibly positive reasons why they should produce a modern play, and so they decided to do it. Thus began the process of preparing their current audience for the change. They sent educational materials, plot synopses, metaphorical explanations, anything they could think of that might help transition a classic-loving audience into one that also enjoyed modern plays. The following season, Nirvana Rep introduced modern theater to its audience, and the audience began asking for more.

After that first "modern theater" season, one of the staff members suggested that Nirvana Rep consider doing an avant-garde play. This time, the staff did not seem very eager. Avant-garde was too strange, too *out there*, and too foreign.

"I think we ought to do some investigating on this," said Galveston. "We're out of time right now, but at a future meeting, when we have some real time to hash out this idea, I think we should."

At the next meeting, Galveston took a moment to ask if anyone had given the avant-garde idea any thought. Hearing only grumbles, Galveston said, "I should tell you that I'm not a big avant-garde fan, but I did go to see an avant-garde production at one of our competitors, and I actually enjoyed it. It was different. It's not really right for us, but let's keep thinking about it. It may give us other ideas."

And it did. People started consistently bringing new types of theater to the table. Galveston continued to encourage that. And when an idea managed to gain some sort of consensus on its own, then they ran with it. Somehow, decisions developed in this way always seemed to work on the stage and in the box office.

There is nothing unusual about the way things worked at Shangri-La Automotive or at Nirvana Repertory. Stories like these exist at all sorts of companies throughout the country. What was going on has been well studied and supported by all sorts of theories in business, sociology, and psychology. What has never been very clear is how to develop leadership skills. The next few chapters look at why things happened the way they did at Shangri-La Automotive and Nirvana Repertory, and how leadership skills were applied unsuccessfully as well as successfully in these creative environments.

Chapter 3
Effective and Ineffective Leaders in the Arts

"A mature person is one who does not think only in absolutes, who is able to be objective even when deeply stirred emotionally, who has learned that there is both good and bad in all people and all things, and who walks humbly and deals charitably."

– Eleanor Roosevelt

Maturity

In all those "content expertise" books that you can find on Amazon or at the airport, one thing which is never mentioned, but which becomes blatantly obvious the more you read them, is that the best way to become a good leader, even a great leader, is to learn how to do it over time.[1] Yes, the real magic key to solid leadership skills is something we all already possess to some degree: maturity. There is even research that has ventured to tell us that there is a causal relationship between time-span increase and leadership capacity.[2] In plain terms, the older you get, the better you get. That makes sense. As we mature, we become capable of not sweating the small stuff, of choosing our battles, of knowing who is going to do what, how, and why.

However, that begs a question. Is leadership something that can only be attained over time? Ultimately, are we all doomed to wait until we mature enough to become great leaders, like a great bottle of French Bordeaux? It is a question that has been pondered a great deal since the military started its leadership training decades ago. For the military, leadership is simply a collection of skills and abilities that keep people engaged effectively in activities.[3] The military has never been very interested in what sorts of things the creative mind can bring to the fore of their operation since they are primarily concerned with how well soldiers follow orders. Sure, there are creative endeavors within the military, but even those are formalized with policies and procedures.

So is there some way of learning to be a great leader faster than by using the traditional method of waiting until one matures to the appropriate skill level—something that many will never do, and others achieve only at the end of their professional careers? In order to find the answer, we study many leaders and see what makes them tick. We see who is successful and who is not successful, and why.

What is surprising is that if you look at some particular aspect of leadership in the arts, a theater director, for example, and you look at successful leaders, you find that maturity level seems to have little or no correlation to success. Teenagers can be solid directors, capable of pulling together large teams, traversing through thorny issues, and hitting opening night successfully. Better than that, they know how to let a project go and look to the next one without being stuck in a rut or being blinded by connectedness to their organization. It is because of this unique talent of arts leaders that I set out to study what makes them different from, say, managers of Wall Street firms or corporate leaders or military leaders. While a nineteen-year-old can be extraordinarily successful as a theater director, the same probably could not be said for most teenage corporate America or military leaders, if there are any.

What came out of this study were two things: First, I found some consistent behaviors that successful theater directors engage in that seem to be at the root of their success. All successful leaders in theater have a handful of traits that impact how they work with their teams, and when they apply those traits, the final work of the group is more potent and powerful than when they do not. The second thing to come out of the study was a dichotomy regarding the different "kinds" of directors. They all have different ways of behaving as they apply the traits of excellent leadership. Some of them (those who are not effective) can easily fall into each of these categories as well for their lack of those traits. The important thing to note is that different kinds of behavior lead to both effective and ineffective leadership.[4]

While it is relatively easy to simply create labels for different types of leaders, and that has been done innumerable times by writers of management books, the labels defined below were developed via observation of a repetition of behavioral styles as found in theater leaders.[5]

While most people display more than one of these stylistic tendencies, they are fairly useful for helping to pinpoint what styles you use. Not everyone has strengths in all of these areas. In fact, very few people do. However, when someone is completely ineffective in any one area, he or she demonstrates ineffectiveness in overall leadership ability. In other words, success can be found in a number of ways. One can be successful by demonstrating only one of these styles and being neutral on all the others. But failure occurs whenever someone is the opposite of, or ineffective at, any one of these styles. Demonstrating ineffectiveness at any one of them showed ineffectiveness at leadership, regardless of talents in other stylistic areas.

Instrumental Leader

This leader has been cited as having clear expectations and providing necessary resources to accomplish those expectations, and provides rewards for doing so.[4] The instrumental leader provides the necessary support, guidance, and mentorship to allow subordinates to thrive.[6] An instrumental leader is someone who wants to agree with their staff on the "goals" but leaves it up to them "to do the work in their own style." Remember Everett Galveston, the second CEO at Nirvana Repertory Theater? He regularly showed interest in good ideas, and when one was presented in a meeting, he asked everyone to do research to determine the efficacy of the idea. The team took on the duties assigned to them with the expectation that they would be rewarded with their CEO's satisfaction, regardless of what they ended up reporting. Everett provided clear expectations, his staff had the resources necessary to accomplish them, and they knew what to expect when they finished their work.

Are you a leader who provides clear instructions to your staff? It is a tough question for someone to answer clearly, because we all think we do this. However, there are some signs to look out for. Do you find that you don't usually have to explain things to your staff, because they get things right? Do you give them instructions and find them getting things done the way you expect? Do you have a staff that asks for something when they need it to get their job done, rather than just not getting the job done? If you answered yes to most of the above, you are likely proving successful as an instrumental leader. When your staff members inform you of a project success, whether it is simply a benchmark or project completion, do you find yourself a little proud that the person is on your team? Do you feel a sense of ownership in their success? If you do, then you may be experiencing the rewards of being good at instrumental leadership.

An ineffective instrumental leader has difficulty making clear decisions and/or does not appear to have effective knowledge of the work being done. This leader is sometimes seen as doing nothing. What is odd is that someone who is good at instrumental leadership often feels as though they don't do anything. The one who is ineffective is seen as someone who does nothing. This is the leader who doesn't provide guidance but points out

where it can be found. Are your team members incompetent? Do you find that they simply cannot manage to do anything right? Guess what? That probably is not their fault. In addition, even if they are incompetent, it is your responsibility to step up and find a way to support them so they can be successful. Give them very clear instruction and very clear definition of what the rewards will be for success and what the consequences are for failure. Do it often and on everything. Soon, you will find you need to do it less and less. If you don't know how to do exactly what it is you need them to do, find out, or find out who can teach them.

A theater director does not know how to play every single character, but he or she talks to the actors about their expectations for how the characters will behave and respond, move, speak, etc. They are clear in what the actors should be achieving. They knows how an actor creates a character, even if he or she isn't creating the one at hand. They inform their actors that they will let them know their success by their approval, and their failures will bring them notes for correction. Failure to try is rewarded with dismissal.

Charismatic Leader

The next style of leadership that can be found in the theater is represented by the Charismatic Leader. This leader has been cited as having pure charm, style, and panache, which seem to encourage others to work in a dedicated fashion.[7] This one is really easy. It is the person who is so likeable that you want to work for them and make the company successful. As an employee you are rewarded by simply getting to spend time with this person. People skills are vastly important to this leader, and take precedence over the technical. This is okay.

Do you just love to interact with people? Do you enjoy meetings because you get to see people, and not just because you get to solve issues? Do you like to discuss things? Would you rather conduct interviews than do the actual hiring? Do you thrive at social events, and love to have your team come in just to chat about stuff? Do you let the technical people handle the technical things, because your job is to keep everyone together? If this sounds familiar, you may be a charismatic leader. These days we hear a lot about leaders who are good at their jobs and *also* very charismatic. Sure, there are many people who possess multiple traits, but it is okay to simply be exceptionally charismatic.

An ineffective charismatic leader appears to "turn people off" through rude or inappropriate behavior. Sometimes this person is cited as "not a people person."[4] These ineffective charismatic leaders do the reverse of being social. They are antisocial. They not only shun the spotlight, they shun people altogether. In theater, isolation from social interactions is deadly. Theater is all about social interactions. And when a person's energy is viewed as negative, he or she fails. Ineffective charismatic leaders end up destroying a team simply because they become the catalyst for disdain.

Team members rally around their dislike of their leader. And that dislike spreads faster than a flu epidemic. It also stays just under the surface, creating an ugly tension that blocks the forward motion of a team.

In the theater, there are directors who aren't incredibly skilled at the basics of directing. They do not stage a scene particularly well. They don't guide actors particularly well. They don't communicate or build consensus. But their incredible personality makes them intensely likeable. And their teams, their casts and crews, find great pleasure in being involved in a project with them. What happens, as a result, is that the skilled people working with these directors rally together, honor each other's talents, and bring about a great production because they find ways to self direct under the charismatic environment of their director. Charismatic directors often achieve incredible results. As long as the charismatic leader isn't ineffective in some other trait, as long as he doesn't become an obstacle to his team's progress, the charismatic leader is successful. He brings his social ability, outgoing nature, and charm to the table, and then stays out of the way of the work. The happy team takes care of the business at hand.

Personable Leader

The personable leader is the leader who has genuine concern about individuals or groups of subordinates. This leader exhibits genuine respect for constituents. The distinction between a charismatic leader and a personable one is that a charismatic leader is kind, charming, outgoing, and positive. The charismatic leader appears almost super-human in terms of energy levels and intelligence. The personable leader may not be so outgoing and good-natured, but he or she really cares about their fellow man. He or she cares about the lives, the needs, the wants of the people who surround them in the work setting. They listen to others and ask questions about how you are doing, how you are feeling, and do you have any suggestions for making things better.

Do you think your team members are brilliant? Do you think they are really good people? Do you think they are incredibly capable or decent or valuable? If you find yourself regularly thinking about how great your team members are, you are likely displaying the traits of a personable leader, because you have respect for your team.

An ineffective personable leader displays frequent emotional outbursts, a genuine disrespect for constituents, and difficulty connecting to individuals on a personal basis. Remember John Precinski, the CEO at Shangri-La Automotive who came in with the goal of setting the company on the right path no matter what? He didn't present his own vision, but once a vision had been clarified he was damned sure everyone was going to work toward it no matter what, and if they didn't, they would be sent packing. He failed at being personable. It was almost as if he blamed people for not being passionate about the path or the process, rather than helping them to be passionate, or bringing them into the mix to such a degree that they could reshape the vis-

ion into something they could get behind. Sometimes, the path a person has to take is to leave a company because he can't get behind the vision, but in theater, no one ever goes in thinking there might be one or two who have to be let go because they aren't getting the vision. Everyone nurtures the vision together, participates together, works together, and the personable leader is at the helm of that process.

John Precinski gathered the information he wanted and then gave directives. When people did not like the directives, he fired them. John Precinski was never concerned about people. They needed to feel some sense of empowerment, and John Precinski never cared. Nor did he really value their opinions. He never demonstrated that he was able to listen to, synthesize, and incorporate their thoughts into corporate actions. Certainly, it is not always possible to accept every idea offered to you. However, John Precinski listened only to give the appearance of listening. He selected this idea over that, often going with his own idea, and then set out the directive. He never demonstrated actual care or concern for those he worked with. Not surprisingly, those he worked with responded in kind. Eventually, their lack of care for John Precinski was exactly what ended his term as CEO.

Ask yourself this: when someone brings an idea to you that you *think* is not right, or that conflicts with your own idea, do you explore it, try to understand, and really want to understand why it could easily be the best idea? Do you do this because you really like the person who brought the thought to you? Because you value the importance of their ideas? Or do you know that it is not the best idea, it hasn't been thought out well enough, or it comes from someone who is less informed than you, so your opinion is the better one? In other words, does your own maturity make you the more suitable person to make leadership decisions? If you think it does, you may be an ineffective leader because you lack personable skills.

Inspirational Leader

An Inspirational Leader is a leader with the ability to inspire others to perform through words or deeds, either as a mentor or as a model. An inspirational leader will tell others they don't want them to be "loyal to them." They want everyone to be loyal to their mission! They often exhibit this behavior through extreme levels of organization or accountability. When Brian Artsman founded Nirvana Rep, he made it clear that he knew everything there was to know about classic theater, and that he would continue to be the most expert on the subject that he could be. When it came to classic theater, he was always out in front. His knowledge and understanding of it was inspirational.

Inspirational leaders do exactly what it sounds like: they inspire others.[8] We all know someone who is pleasant all the time. They are happy, they smile, they always have a good thing to say and never have negative comments. They inspire us to be more positive. But this is more than charisma. They also embody knowledge. They are sensitive to challenges and issues.

The charismatic leader serves as the ego for his followers. But the inspirational leader is a representation of the follower's ego. He or she is the role model.

We all know people who seem to handle everything that is ever thrown at them with great ease. They have three plates full of tasks, but they manage to juggle it all and never become stressed. You can ask them for something at the height of their workload, and they can easily drop everything to accommodate you without missing a step. They inspire you through their actions.

An ineffective inspirational leader is often disorganized or unaccountable. Have you ever seen a desk cluttered with papers in your boss's office and at the same moment thought, "This person is an inspiration"? Probably not. Sure, there are messy people who can inspire us, but usually the horribly messy desk of a leader is a sure sign that he or she is failing in the inspiration trait. Is your desk messy?

How about the boss who tells you that the people in such-and-such department really screwed the team with their failure? Or the person who says he or she simply has not had enough time to consider a proposal appropriately. They are usually the people who always have a good reason why something has not been done or has not been done right. No one is ever inspired by the person who has excuses or places blame. Brian Artsman never had to do either, because he made sure he knew what he was talking about.

Trusting Leader

Next is the Trusting Leader. This leader is one who is cited as being capable of generating a solid and trusting relationship between self and subordinate or other constituent groups.[4] Once this type of leader decides they "like and trust you," you will be in good graces and can do no wrong. In Artsman's interchange with his scenic designer, he indicates a preference for one color scheme over the other and the scenic designer nicely suggests a rationale for a different path. Artsman trusted the content expert, the designer, to make the better decision about the particular content. In some ways, it may be like a parent allowing a child to make mistakes and learn from them, but employees do not like to make mistakes, so they venture forward with unique and different ideas only when they see good potential for success. They have to be trusted to do the right thing or learn from their mistakes and to not make mistakes often.

An ineffective trusting leader is viewed as unreliable or inconsistent in behavior, often through the exhibition of purely ego-driven behavior or reliance on outside individuals. Arthur Fine had a new vision for Shangri-La Automotive that was based entirely on his own expertise. He thought he would be smart in presenting it very slowly. He did not trust his staff on two fronts: first, he did not trust them and their expertise to help shape the vision, and then he did not trust them to participate in his vision. That lack of trust doomed him to quick failure. Arthur Fine made decisions based on

his own ego. That ego was the one thing he trusted, and as a result, he never showed his employees that he trusted their thinking, their ideas, and their decisions.

<p style="text-align:center">* * * * * * *</p>

The final three styles are really the big ones, both in theater and in every sort of business. Every effective theater leader studied appeared to have at least some skill in each of these areas, even if it was not a strong suit. Moreover, the vastly successful leaders exhibited expertise at all three of these traits.

Communicative Leader

The first of the final three is the Communicative Leader. This leader is cited as one who utilizes effective listening skills and provides frequent and appropriate dissemination of information.[4] Everett Galveston listened to ideas, even if they were ones he was not particularly enamored with. He considered them seriously. In the case of avant-garde theater, he heard the idea, and he studied it. He asked for input and he went to see an avant-garde production. He really listened to the idea and gathered information before sharing his conclusion. And when he came to a conclusion, he reported it. Avant-garde was a good idea, but not the right one. He did not try to subtly drop hints about his conclusion, as Arthur Fine did when he let out bits and pieces of his new vision for Shangri-La Auto.

The communicative leader legitimately tries to solve problems and engage in solution finding by discussing issues and challenges with others.[9] Sometimes, almost to a fault, this person wants to discuss things before moving forward. They fight making quick or snap decisions.

The ineffective communicative leader withholds information or fears conflict and thereby avoids difficult communication. When communication is difficult, it is because people have passions that run in opposite directions and conflict. At the heart of that statement is that people are passionate about something. The effective leader channels that passion through communication. The ineffective leader avoids it.

Consensus Leader

The second of the final three is the Consensus Leader. This leader is cited as one who is focused on building commitment to an idea, project, or plan, and generating buy-in for that idea.[4] Often, the consensus leader is referred to as a "team player" by exhibiting a need for team cooperation and commitment. You can probably see why effective communicative leaders likely display some consensus leader talent and vice versa. The two are not only compatible, but they also go hand-in-hand. Everett Galveston walked into Nirvana Rep with a vision he wanted to pursue. Rather than lay out his vision, or even drop hints about it in pieces, he simply shared his passion for a particular subject: modern theater. He shared his passion with the staff. He let

them develop their own thoughts and ideas about it. When the time came, he let them develop the vision. Maybe Galveston had really been thinking of adding a modern theater festival to the current classic presentations at Nirvana Rep. Maybe he had hoped to replace all their productions with modern theater. It does not matter. What matters is that the staff was able to reach consensus on a vision not because Galveston wanted them to or told them to, but because they found, on their own, the value in such a vision.

The ineffective consensus leader fails to generate team participation in terms of both consensus and camaraderie. Certainly, Arthur Fine was a failure at consensus leadership. He simply laid out his vision and expected people to buy in. But John Precinski failed in consensus leadership as well. Yes, he listened to everyone's input. He encouraged their participation, and then he set a course. However, when there were complaints, he did not work to incorporate the root of those complaints into the discussion. He simply drew a hard and fast line in the sand and dared people not to be a part of the consensus.

Collaborative Leader

The last of the final three, the biggie in theater, is the **Collaborative Leader**. This leader is cited as one who seeks out new ideas from subordinates by encouraging them to think differently about their work and participate in problem-solving.[4] The story of the scenic designer suggesting a different color scheme is a prime example of collaborative leadership. Yes, Brian showed trust for his content expert, but he also encouraged finding solutions. This leader also utilizes the input of subordinates to develop new ideas even if they are "out of the box" ideas. Everett asking for new ideas for styles of theater the company might attempt was a clear demonstration of collaborative leadership.[10]

The ineffective collaborative leader dictates direction and expects constituents to follow blindly and is sometimes referred to as the *do it my way* leader. Had Brian Artsman said, "Red is a nice color scheme, but I would rather go with blue," he would have demonstrated ineffective collaboration.

What is interesting about this is that making one decision to go with blue instead of red does not an ineffective leader make. However, there is a cumulative effect that occurs with decision-making.

The most effective leaders demonstrate consistency in one or more of these categories. Each category can be examined in a number of ways, but each is a general style of leadership. Understanding the skills each style exhibits is the key to knowing how to cultivate the creative mind to act and react appropriately depending on the circumstances, situation, and type of people you are dealing with to function as an effective leader.

1. Maxwell, J.C., *The 21 Irrefutable Laws of Leadership*. 1998, Nashville, TN: Thomas Nelson, Inc.
2. Goodman, P.S., *An empirical examination of Elliott Jaques' concept of time span*. Human Relations (New York), 1967. **20**(2): p. 155-170.
3. Anonymous, *Army leadership: competent, confident, and agile*, Army, Editor. 2006, United States Army: Washington, DC.
4. Rhine, A.S., *Leadership in the theatre: A study of the views of practitioners on effective and ineffective styles*. The International Journal of the Arts in Society, 2009. **4**(2): p. 387-398.
5. Aaron, L., W.J. Hrapchak, and M.J. Kavanagh, *Consideration and initiating structure: An experimental investigation of leadership traits*. Administrative Science Quarterly, 1969. **14**(2): p. 238-253.
6. Schriesheim, C.A., *Task dimensions as moderators of the effects of instrumental leadership: A two-sample replicated test of path-goal leadership theory*. Journal of Applied Psychology, 1981. **66**(5): p. 589-597.
7. Conger, J.A., *Toward a behavioral theory of charismatic leadership in organizational settings*. The Academy of Management Review, 1987. **12**(4): p. 637.
8. Bass, B., *The inspirational processes of leadership*. Journal of Management Development, 1988. **7**(5): p. 21-31.
9. Eriksen, E.O., *Leadership in a communicative perspective*. Acta Sociologica, 2001. **44**(1): p. 21-35.
10. Ansell, C., *Collaborative governance in theory and practice*. Journal of public administration research and theory, 2007. **18**(4): p. 543-571.

Chapter 4
Ineffectiveness

"Ineffective people live day after day with unused potential. They experience synergy only in small, peripheral ways in their lives. But creative experiences can be produced regularly, consistently, almost daily in people's lives. It requires enormous personal security and openness and a spirit of adventure."

– Stephen R. Covey

Synergy

There is a maxim in business about "synergy," which tells us that when people come together as a group to work on something, the result will be greater than the sum of its parts. As it turns out, there is evidence to suggest that the maxim may not always hold true. In fact, what appears to be the case is that brainstorming in a group often turns out to be less effective than when people brainstorm individually.[1]

There's something to that idea, however. For years, we have heard of "groupthink," where people in a group can have a tendency to go along with one another rather than dispute an idea or put forth a conflicting thought. Clearly, this issue can occur in brainstorming; and brainstorming is the start of a group's creative process. There is also a phenomenon called "social loafing," which is exactly what it sounds like. Social loafing tells us that people

will do less when there is a group of people, because individuals believe someone else is going to do the actual hard work.[2] Reaching consensus, or even developing an idea, is hard work, and people cannot simply do it the way they execute a task, because it involves human interaction at both a logical and an emotional level. There is not a stated way to go about coming up with a new idea. There is not a formula for us to follow. There is not a guidebook. Instead, there are those dreaded personalities that come into the room and function as part of the creative team. They are full of ego, and everyone wants their idea to be the one chosen. So some of us, many of us, do not jump into the fray. We sit back and let others do the work. We are social loafers. Social loafing is often not loafing at all, but actually a way of avoiding the challenges involved in being creative, of developing ideas as a group. There are many ways that we avoid work, and social loafing, while it can simply be about not pulling your weight because you don't have to, is definitely work avoidance.[3]

Synergy is blocked in a number of fascinating ways, and they have all been meticulously studied and documented by academics as well as writers of airport books. In fact, it seems that business experts are very good at documenting why things *don't* work. They study how failure occurs at an alarming rate. We can only hope that the approach is intended to discover exceptions to the rule. Because as much as there is in the world to *not do*, leadership would be so much easier if someone could just tell us what *to do*. One way that synergy is disrupted in brainstorming that embryonic stage of creative idea generation is through something called production blocking.[4-5]

Have you ever been at a meeting where there seems to be an unusual amount of passion and verbosity? And at that meeting people keep throwing out good ideas and expanding on each other's thoughts that it almost seems dizzying. Suddenly, someone says something that strikes a chord with you, and you realize that you can expand on what they have said in a profound way. But you realize you can't get in a word edgewise. You try to interject here or there, but the passions are running so high that you cannot even say what you need to say, so you let the current thought run its course before you decide to speak. Maybe someone even sees you have something to say, and gestures that you should wait just a minute or two until the passions cool a bit. At some point, when the topic has wound down to a reasonable conclusion and the moment for you to share your profound contribution has finally arrived, you plan to take the floor, only to discover that you've forgotten what your contribution was. Perhaps when that moment arrives, the topic has since been so altered and sent down different paths that your idea is no longer relevant. In any case, the production of an idea by you has been effectively blocked.

One more issue can threaten synergy in those brainstorming sessions with groups. In this case, you rather block your own ideas or thoughts. Here is what happens: The discussion is going along nicely, and people are tossing out ideas. Some of them are quite profound and very intriguing to you. In fact, some of the ideas have you thinking they are downright genius. You wonder where all these incredible thoughts have been hiding. You also have

an idea of your own, but compared to what you are hearing, you think that what you could contribute is small and insignificant. After listening to all the best and brightest, you decide that there is no point in tossing out your idea, as you can see that it will fall by the wayside next to the shiny and brilliant ideas that have already been floated. You are apprehensive about your evaluation of the potential value you could contribute, so you decide to censor your idea out of the conversation. This apprehension is another form of disrupting group synergy in brainstorming.[4-5]

There have been a significant number of studies about how people solve problems.[4] The news is extremely relevant if you have to coordinate the efforts of creative people. For years, we have "managed" people by creating policies and procedures. We have defined exactly how things should be done so that mistakes do not occur. We ISO 9001, total quality management, and Six Sigma everything to the minutest detail. We have created a work environment where managers are supposed to follow everything in logical order and get their subordinates to do the same. All of that makes perfect sense, because those psychologists who study how we think discovered a long time ago that people think in a pretty predictable fashion, one thought after the other, like building blocks.[4] That makes sense, because it is how we are taught in school. You learn addition first, and then subtraction, multiplication and then division, followed by fractions. As pieces are added, you work your way up to algebra. Learning is done sequentially. Work is managed sequentially. People think sequentially.

As it turns out, creative minds do not think quite that way. What we suspect is that creative minds do not think sequentially at all. Creative minds seem to have the abililty to think both vertically and horizontally at the same time. They make associations between different thoughts that come from all different directions and places. Creative people can bounce around from one area of thought to a completely different one with ease. In fact, they seem to need to do this to be successful.[6] Certainly there is a point where bouncing around from one idea to another without any focus becomes a distraction, but once in a while, I wonder if we don't overdose on those medications that "help you focus." Because if you think about it, lack of focus is what contributes to creativity.

That means that getting the input of others can stimulate the bouncing around from one thought to the next, taking those building blocks for an idea and putting them to use. So while brainstorming in groups can be, counterintuitively, less effective than brainstorming individually, creative minds can use brainstorming to propel ideas forward. The question then becomes, how do we make certain that the brainstorming is proving to be beneficial? How do we make certain that everyone is confident enough in themselves and in the process that they don't self-censor their own ideas, or feel intimidated by the more aggressive participants? How do we ensure that everyone is sufficiently motivated so that they participate and do not become social loafers? How do we make this ambiguous nature of idea generation without clear guidelines and endpoints safe enough for everyone to participate?

What is interesting about this situation is that we have created a bit of a paradox. The questions we need to answer about how to make this group generation of ideas amongst creative minds require us to create the very rule and policies that seem to conflict with the creative types. So the question is whether or not we can use our linear line of thinking in an adaptive fashion that will help to constrain, but not restrain, the creative mind. The answer is a resounding "yes."

The Fragile Ego

Everyone has an ego. Freud tells us that we use the ego to mediate our otherwise irrational responses. When someone says, "You are ugly," we do not pull out a gun and shoot them. Our ego keeps us in check. This is not to suggest, however, that when someone calls me ugly, I do not want to pull out a gun and shoot them. Modern vernacular has us thinking about the ego as the thing that makes us a bit proud of ourselves and our work and our actions. When someone calls me ugly and I simply smile and say, "My mirror tells me otherwise," we might say that I am driven by my ego. We might say I am egotistical.

Creative people tend to have fragile egos. In fact, it appears that creative people tend to have egos that are far more active and driven than the egos of those who are less creative or function in a less creative environment.[7] When I was growing up my mother called these types of people "sensitive." They are more easily influenced by others. They are more easily hurt. They seem to be fragile.

Have you ever been in an evaluation with an employee (or maybe you were the employee) and the discussion started about some particular topic that required addressing the employee's work? It could be perpetual tardiness, or cutting corners on projects, or taking long lunches, or speaking inappropriately in the office, or any of a number of things. You tactfully and delicately, almost with a brush of humor, note the problem to the employee (or have it noted to you), and there is a moment of silence followed by a stunned sound of shock from the employee, followed by a long-winded defense for why the observation is wrong. This is nothing new or unique for the employee (or for you or for me), because no one likes to be criticized. It bruises the ego. It tells the ego, "You have not been doing your job as well as you should have or you would have been able to moderate this behavior on your own."

In a rehearsal, a director essentially spends countless hours telling actors what they are doing wrong. The rehearsal process is basically a venue for corrective action. The director's job is to coordinate the work of several individuals, and in the rehearsal, each individual is trying to *find* a character. The process requires a director who can help ensure that what one actor finds doesn't conflict with what the others are finding. Ultimately, the entire process is about developing a play where all the characters work, live, breathe, and function together in a world, albeit make believe. Through the

entire rehearsal process it is the rare actor who is offended when the director criticizes the choices that actor makes. It does happen occasionally, but it is fairly rare. Why?

Well, consider that on face value, the actors are all there to achieve the exact same goal. They are trying to create a new play. But if you dig a little deeper, you realize that each actor has his or her own important piece of the larger puzzle. They all interact and interrelate. They are all important ("there are no small roles, only small actors") to the process and the product. No one is marginalized or left to their own devices. Each character has a specific, unique function. On the first day of rehearsal, no actor knows what character he is going to *find* by opening night, but as each works on his or her unique character, they develop the larger creative goal together.

In business, when dealing with the creative mind, we have to take the same approach. The ego is fragile, but it seems to be more willing to accept feedback, even critical feedback, when that feedback is not in any way in comparison to the work of others. Taking a project team and identifying unique, individual ways that each member approaches the overall picture does two things: First, it gives each team member ownership of their own work and perspective, and we know that providing intrinsic value like this to team members improves results.[8] Second, it allows each team member to have his or her own character to play. Corrective action now is clearly about helping each team member be successful in finding how his or her role connects to everyone else, and is less a comparison about performance of one individual as held up to the next.

Communicating and Listening

There is another thing that happens with creative types that is associated with ego. It is also reflected in the theater when we assign individual roles to each actor. Creative types seem to be better able to hear, to listen, and to communicate when you can approach a subject as if they are the center of the discussion. It is an internalization of problems. Creative people do not examine the outlying structure of an issue and see it as something distinct from them. They internalize it. They see finding a solution as a personal challenge. It is not about simply finding a great solution, it is about proving that they are capable and wise and successful. If they fail, it is a personal failure. If they win, they need to know that the win was not only good, but that it was as good as it could possibly be. This makes communicating with creative people difficult.

What a good director does is ask a lot of questions, which allows actors to frame the answers in terms of their own characters. Sometimes the questions are asked in front of the entire cast, and sometimes they are asked privately. They could be as simple as asking, "Why do you think your character says this?" to asking, "Is your character thinking about suicide at this point?" The latter is a bit more deceptive, and almost manipulative. When a director asks a leading question like this, it plants a seed. The actor may

respond that his or her character is *not* thinking about suicide at this point, but because the question has been put on the table, the actor cannot erase the memory of it. At this point in the play, every time it arrives in rehearsal or performance, the actor will have a trace memory of the consideration of suicide. Once the toothpaste has been let out of the tube, it cannot be returned. Even if the actor is convinced that his character would not think about suicide, the actor himself cannot help but wonder about the topic for his character.

John Precinski was well noted for his punctual staff meetings every week. He would gather his engineers together and discuss pertinent issues of design concepts that were being worked on. Mostly, Precinski provided information necessary for continuing work and to ensure that everyone had what he felt was important for them to know. He withheld much information which he felt was not in their purview, but that is a topic for another chapter.

On occasion, the topic in the staff meeting was one of great importance to Shangri-La Automotive. It would be a topic that had to do with where the company was headed, or how it should approach overall marketplace aesthetics, or even how the staff should be structured in order to operate more effectively. Precinski was a man who had studied "management" with a keen eye (though never with that eye in a management book), and he knew that it was essential to get everyone invested in a decision and a solution. Precinski was a man who believed that while consensus was impossible (it is not), if everyone had a chance to participate in the discussion, then a democratic-style decision, with a majority ruling, was the way to operate.

So on one particular Friday afternoon, at the weekly staff meeting, Precinski brought up the idea that the following year, all color aesthetic was likely going to be around red-tones, specifically because the fashion designers were leaning toward red-tones. There was a bit of outrage from some staff members, who thought the idea of following fashion designers into automotive interiors was silly. One even remarked, rather vocally, that there was no evidence to suggest that one followed the other, or that there was any correlation whatsoever. Quickly, two schools of thought emerged in the discussion, one that thought it might be wise to try to follow fashion trends, and one that thought timewise it would put interior design behind trends due to length of time from design to market. Two-thirds of the people in the room had plenty to say on the topic, and the debate raged for almost an hour. When the discussion slowed a bit, Precinski cut one of the more vocal debaters off and turned to a woman who had said nothing the entire time. "Susan," he said, "what do you think?"

The forty-something redhead was a bit stunned. She really did not have a whole lot to add to the discussion, and that was why she had remained silent. The entire room looked at her, putting her in the spotlight, and Precinski waited until she spoke.

"I don't know," said Susan meekly. "I guess we could try it."

One of the men who was adamantly against trying to follow fashion trends immediately let out a loud guffaw, but Precinski cut him off, saying, "I want to hear from everyone before we go any further. Terry, what do you think?"

As you can imagine, Terry was equally ill-prepared and disinterested in commenting, as were the several other people put on the spot to present their thoughts. They each volunteered very little, and none of them volunteered anything that could advance one argument or the other. These were people who simply didn't think by being in a large debate. They needed to take the information, soak it up overnight, and then perhaps share their thoughts privately. Precinski, in an effort to include them, actually ended up victimizing and minimizing them.

At one of his staff meetings, Everett Galveston had a similar challenge. There had been some hallway discussion about doing a classical musical in the season, and Everett felt it was important to put the issue on the table and discuss it, to see how everyone felt about the topic. Galveston started by saying that this was a brainstorming session, so practicality was not welcome. Yes, musicals were more expensive, and it is true that they require different talents, but those practical issues would be addressed later, if the fundamental issues about the value of doing classical musicals had been determined.

Next Galveston reminded people that they were not to criticize each other's thoughts or ideas. This was not to be a debate, but a discussion, and that all ideas could be put on the table, but that they were not to be labeled. The discussion ensued, and soon, as at Shangri-La Automotive, two different positions emerged. One group felt that the presentation of musicals diluted Nirvana Rep's brand, as it had always focused on non-musical literature. The other position was that musicals were classical theater as much as non-musicals were, and that it was time that they were represented.

Because criticism was not allowed, and on several occasions Galveston had to remind the assembled group, the discussion was actually very friendly. Eventually, oddly enough, the group that was opposed to presenting musicals started to come to the opinion that there really was no good reason not to present musicals (practical ones aside), and eventually, something close to consensus was achieved. It was only close to consensus because, like the Shangri-La Automotive discussion, only two-thirds of the group had really participated in the discussion. Once the meeting was over, Galveston's assistant, pleased with how the meeting had gone, asked if he would like her to begin compiling a list of all the practical concerns that would need to be addressed if Nirvana Rep were to produce a musical.

"Not just yet," said Galveston. "I'm going to wait until I get emails tomorrow from all the introverts who didn't express their opinion today before I decide how we move forward."

While there are creative as well as non-creative introverts and extroverts, creative types need the value of their contribution recognized the way *they* need it recognized. What John Precinski missed altogether, Everett Galveston got completely. People have different ways of communicating, and it is

our job as their leader to figure out how it is they communicate best, and to nurture that level of communication and value it.

Constraint Versus Restraint

One thing creative types cannot abide by is restraint. Give them boundaries and they simply cannot do what it is they are supposed to be doing. In business, this can be a challenge, because we live in a world full of restraints. Most often, financial restraints slow or stop the growth of an idea or a project. But restraints on creativity can do the exact same thing. Telling a creative type that they must work within certain boundaries is certain to stifle creativity. Yes, there are some generally acceptable constraints that we all must work within, but beyond those, a good leader needs to keep the world wide open for his or her people with creative ideas.

Actors know that they will be restrained by the physical space of the stage. This is accepted (or sometimes not, depending on the theater and the production). When it comes to creating their character, only certain restraints exist, usually physical. Actors are, however, constrained by other issues. The costumes that are designed for the character constrain a performance. How other actors move and behave will constrain a performance. In fact, the way everyone else works on a production is, in some way, a constraint for each actor.

In a business setting, we find that without restraining, or totally limiting, action on the part of a creative, there often is a need for constraining, or partially limiting, the creative juices. Creative folks can wander too far afield and spend too much time and money on ideas that cannot ever be produced. It is the leader's job to ensure that those ideas are somehow constrained enough to be able to come to fruition in some practical manner, even if practicality is set aside to allow creativity to occur. There is, however, a fine line between what is restraint and what is constraint, and creative people with fragile egos tend to dislike both.

Remember planting that seed about a character considering suicide? Perhaps it is manipulation, but that was a way of constraining an actor without actually laying out a restraint. For the business leader, the idea isn't quite so simple. Creative types can't be so easily manipulated, though one can ask if "this has been tried," or "that has been considered," just to plant some seeds. Those thoughts, however, are variations on providing a sample. They are a way to suggest that something could be looked at one way or another. We know that one of the best (or worst) ways for constraining creativity is by providing examples.[9] Examples are not restraints in the most technical sense of the word. But what examples do is throw into the mind of a creative person a box within which others have worked. It seems that creative people can push the boundaries of that box, but when examples have been provided, they have a difficult time simply "going wild."

At one particular meeting, John Precinski had a new policy that he wanted instituted. It had to do with employee morale. He drafted a statement that suggested that those who behaved in ways that were damaging to employee morale could be reprimanded, punished, or terminated. He presented the new policy to the staff, expecting overwhelming support. Precinski believed that everyone wanted good morale.

There was not a strong showing for the policy. In fact, the only vocalization about it was negative. There was bickering about whether such a policy was even needed, and there was debate about whether it was appropriate to discuss in a staff meeting. There was questioning about whether this was going to be brought before the board. Someone suggested that they look at similar policies of other organizations, but Precinski silenced that idea. Other organizations certainly had similar policies, and if they didn't they should. This, he felt, was a matter of collegiality. He offered to take the draft text back, make some alterations, and return at the next meeting with new iterations. He did. There was similar discontent with the policy, similar discussion and rankling, and Precisnki said he would continue to work on it. This happened four or five times. Eventually, Precinski simply forced the policy on everyone and that was that.

When Brian Artsman wanted to codify what sort of artistic goals Nirvana Rep had for itself, he brought about forty different sets of artistic goals to the staff meeting, from theaters of various styles and sizes. Some were quite far afield from Nirvana Rep, though they had some choice wording. Others were very similar to Nirvana Rep. The goals were passed around the room while routine information was being disseminated, and then Artsman grabbed an easel and a pen and said, "Let's draft a statement." People began throwing out words and phrases, mostly from what they had seen in the examples, and as they went along, they deleted certain words, added others, made additional changes, and fine-tuned. It wasn't exactly a brainstorming session, because the team was *creating* a new artistic statement, but it didn't exactly feel like a team project either. There were no parameters or restrictions set down for anyone. They could be as creative as they wished and were given no manufactured boundaries. Instead, they had created their own boundaries, in their heads, by the examples Artsman had provided. He allowed them to take ownership of the process of drafting the statement, and he did it by giving them very specific examples that he had chosen. Perhaps it was a bit manipulative on Artsman's part, but it was his job to help his staff be as successful as they could be. He did that by constraining without restraining their creativity.

Disorganization

One of the greatest weaknesses of a leader is disorganization. Organization is not a prerequisite for being a great leader, but it sure helps. I tell my students that they need to keep a clean desk. They sometimes look at me as if

I had two heads. "What does a clean desk have to do with being a great leader?" But think about it. When is the last time you walked into the office of someone with a cluttered desk and thought, "Well, they could be a genius"?

Steven Winston, that amiable guy who calmed the waters after John Precinski nearly leveled Shangri-La Auto was a disorganized fellow. His desk was always piled with clutter. He was always running just a little behind, and sometimes a lot behind, with getting a project completed. When people sent him an email asking for assistance, he occasionally got around to answering them. The same was true for voice mail. When someone caught him in the hallway and asked for his advice or direction, he would give it with a caveat such as, "It sounds like a good idea to me," but never with a "Yes, you can do that," or "No, you cannot." Winston didn't make hard decisions. Winston didn't make easy decisions. Winston didn't make any decisions. John Precinski had nearly sunk the company with his authoritarian decision-making, and Steven Winston assumed the role of conciliator. A decision in one direction might dissatisfy someone in another. So Winston made no decisions. What Winston didn't understand was that had he been able to organize his life, his thoughts, his files, and his desk, he might have been able to help his staff make those decisions. A good leader of creative people gives them the difficult work of finding creative solutions. The leader's job is to help them to make sure that the challenges of finding those decisions are not too difficult, or so emotionally painful that they cannot work together to learn about and move forward an idea.[10]

You must now think that I am going to tell you every theater director on earth is organized. Not so. In fact, some of them are incredibly disorganized to the point that they are almost unbearable to work with. But in theater, every director, from the most organized to the most disorganized, has a stage manager, whose function is to keep everything about the production that the director thinks, says, does, or intends, organized. The stage manager keeps copious notes of every discussion or decision. The stage manager makes record of what the director finally says the production should look like, and when the lights go on and off and where the set pieces get placed. The stage manager functions as the brain of the production, and once the director is done with their work, which happens on opening night, the stage manager stays on as a surrogate for the director, making sure that the production remains exactly as the director intended.[11] It is no wonder that stage managers often go on to become successful directors. But even then, they require their own stage manager.

Casting

One of the biggest mistakes a director can make is casting the wrong person. It happens for any number of reasons, and the biggest one usually is *not* that the person simply is not good enough. When the musical *Wicked* was doing out-of-town tryouts in San Francisco, a man named Robert Morse played the wizard. Robert Morse is a legend in theater circles. He is one of

the few actors who has won a Tony Award for best actor in a play as well as in a musical. He was the original star of the musical *How to Succeed in Business Without Really Trying* in the sixties and the star of *Tru*, about Truman Capote, Jr., in the nineties. He's done a number of productions and has made his living in the theater. Robert Morse is not a man without talent. He knows how to get the creative work done. But when *Wicked* opened on Broadway a few weeks later, with the same production virtually intact, Robert Morse was gone, and Joel Grey was now playing the wizard. Joel Grey also has had an illustrious career in the theater, most notably as the Emcee in *Cabaret*. Both men are incredibly talented, so what happened? Well, sometimes even though a person looks perfect on paper, and they have all the requisite skills, when they get in the room with the other creative people, they don't quite mesh. I don't know what happened with Robert Morse, but I am going to guess that the character that he "found" wasn't fitting in with all the other characters that were being found, and the director couldn't help him find something that would match, so he had to be let go.

John Precinski actually operated in the same fashion. If people couldn't match what he had in mind, he let them go. The problem with the slash-and-burn mentality is that it doesn't assume people can and will be able to be successful. What a good theater director does is try and try and try until he simply is unable to help an actor *find* the necessary character, and with an opening date looming, he admits his failure: that he has not been successful in adequately helping the actor, but nonetheless, a new actor has to be hired that he can successfully help, because everyone else is counting on him. The actor becomes a casualty. John Precinski did not know or care about helping anyone get on board or find the right solutions. His attitude was "my way or the highway." Ultimately, several people were happily fired by John Precinski; happily, because they no longer had to work with John Precinski. But what Precinski did was chase away some incredibly talented individuals. The process also managed to stifle the creativity of many who stayed. Eventually, the whole thing led to John Precinski's dismissal as CEO. Precinski may or may not have had the right cast of characters on his staff, but he didn't work to develop them appropriately, either individually or as a team. Only with a great deal of effort can you know if there is someone whom you cannot appropriately reach. But of this you can be certain: If many people on your staff are unreachable, then the person who needs to leave is you, not them. It is when there is one or two or a few that you spend inordinate amounts of time with, trying to help them be successful but failing, that you can begin to know that they may not be the right fit for the company, just like an actor who is not the right fit for a cast.

Rehearsal Politics

One of the great dangers in a rehearsal is when actors start to be political. It does not happen a lot, and it is not typical, but it does occur. One actor feels her character should have a certain emotional response in a scene and that

response will conflict with what another actor thinks his character should be doing. For example, she might believe that she should be violent, angry, and attacking, and he thinks that he should be calm, cool, and aloof. The two characters would look odd in the scene together behaving in ways that do not play off one another. During a break, she goes to the director and starts lobbying for why the scene should be loud and argumentative. The director listens intently and says he is just not yet certain it is the way to go.

Mind you, the director could choose to say, "Well, let's try it that way once, and see how that goes," but by doing so, the director knows they create a restraint. Once the scene has been tried one way, even if it fails to work, the memory of what was "tried" will never be gone. Those actors will always have the imprint of what it was like when they tried it that way.[12]

After rehearsal, the woman asks to speak privately to the director. She begins to tell that director that she feels it is important that they play the scene angry. The director again explains his concern about doing so, and the actress starts to cry, detailing how she has lived through a similar situation, and it was really painful, but that she knows in reality the scene was angry. Her tears dominate the moment, and the director puts his arm around her, calms her fears, and says, "Well, it wouldn't hurt anything to try it that way one time." Emotional manipulation. It is a decision the director would otherwise not have made, and he did it against his better instinct. His creativity has been stifled by emotional manipulation.

Steve Winston was wandering through the cubicles of Shangri-La Automotive one bright afternoon when he overheard one of the designers hollering and cussing at his computer. Winston walked up to the man.

"What's going on?"

"This damned computer is so slow that by the time it finishes processing what I want it to do, I've forgotten the great idea I had for what to do next. I spend more time waiting for this computer than I do getting work done. Seems like a big waste of money and a waste of time."

Commiserating, Winston responded, "Well, we all have to wait for our computers at times."

"Yes," said the engineer, "but I'm the only one who has to do this time-intense graphic animation work. Computer speed has a greater bearing on my job than just about anyone else's."

"I suppose that's true," replied Winston. "We've got some extra money in the capital outlay budget. Let me see what I can do."

Emotional manipulation. A good leader calls it out rather than rewards it. What Winston could have said is, "We have some money in our capital outlay budget. I am going to put together a committee to decide how to use it. I'll make sure you are on the committee." The end result may very well be the same, but when the decision comes from the committee, there will be a built-in level of buy-in. When the decision makes it look like the bestowing of a gift on one employee, the result is almost certain to be animosity. Emotional manipulation is usually heard from the squeaky wheel. In theater, everyone is working together toward a final goal. Squeaky wheels are just so much noise. We ask them to be quiet so the work can get done.

1. Mullen, B., C. Johnson, and E. Salas, *Productivity loss in brainstorming groups: A meta-analytic integration.* Basic and Applied Psychological Review, 1991. **12**: p. 3-23.

2. Latane, B., K. Williams, and S. Harkins, *Many hands make light the work: the causes and consequences of social loafing.* Journal of Personality and Social Psychology, 1979. **37**: p. 822-832.

3. Heifetz, R.A., *Leadership without easy answers.* 1994, Cambridge, Mass.: Belknap Press of Harvard University Press. xi, 348 p.

4. Kurtzberg, T.R. and T.M. Amabile, *From Guilford to creative synergy: Opening the black box of team-level creativity.* Creativity Research Journal, 2001. **13**(3/4): p. 285-294.

5. Diehl, M. and W. Stroebe, *Productivity loss in brainstorming groups: Toward the solution of a riddle.* Journal of Personality and Social Psychology, 1987. **53**: p. 497-509.

6. Sternberg, R.J. and T.I. Lubart, *Investing in creativity.* Psychological Inquiry, 1993. **4**: p. 229-232.

7. Domino, G., et al., *Creativity and ego defense mechanisms: Some exploratory empirical evidence* Creativity Research Journal 2002. **14**(1): p. 17-25.

8. Kirkman, B.L. and R. Benson, *Beyond self-management: Antecedents and consequences of team empowerment.* The Academy of Management Journal, 1999. **42**(1): p. 58-74.

9. Marsh, R.L., *How examples may (and may not) constrain creativity.* Memory & Cognition, 1996. **24**(5): p. 669-680.

10. Heifetz, R.A. and M. Linsky, *Leadership on the line: staying alive through the dangers of leading.* 2002, Boston, Mass.: Harvard Business School Press. xi, 252 p.

11. Stern, L. and A.R. O'Grady, *Stage management.* 9th ed. 2010, Boston: Allyn & Bacon. xii, 340 p.

12. Austin, R.D. and L. Devin, *Artful making: what managers need to know about how artists work.* Financial Times Prentice Hall. 2003, Upper Saddle River, NJ: Financial Times/Prentice Hall. xxx, 201 p.

Chapter 5
Effectiveness

"Coming together is a beginning. Keeping together is progress. Working together is success."

– Henry Ford

The One Book Principle

Wouldn't it be nice if there was a book you could open that told you how to be an effective leader? Every leader on the face of the earth would own a marked-up, dog-eared copy on his or her shelf. We would all be effective leaders, and there would no longer be a need for any more of those airport books, which would be as valuable as any dime-store novel, entertaining us with stories of failure and ineffectiveness; stories that would simply have to be fiction, because no one could fail if they had the book that told them how to be effective.

The problem with the single book that tells us all how to be effective leaders is that every situation is rife with different variables. People, for example, followers, subordinates, colleagues, bosses, leaders, friends, relatives, associates, partners, patrons, customers, buyers, other stakeholders, and the like are all incredibly different. They are so different, in fact, that it would be impossible to assess how they work best, respond best, communicate

best, and associate best, and then feed that all into one formula to tell us how best to be effective. Even if someone could conceive of a computer program into which we could feed all this information and get a detailed description of how to lead best given our circumstances, those circumstances change constantly. Someone quits. Someone is hired. Someone is out sick. A new project has a flaw. Two employees have a disagreement about what color the office carpet should be. You get indigestion. Your wife is upset about something her boss said. The kids are playing their music too loud. I could go on and on. All sorts of things affect us in so many ways that there is no good way to keep it all in check and know how to be most effective as a leader. When business theorists realized this, they developed a new theory! That theory tells us that the best, most effective leaders are those who can adapt to the circumstances they are facing. It is called the contingency theory, and it tells us exactly what we already knew.[1] The world is constantly changing. Being effective requires a certain degree of constant change.

Brian Artsman had cast a production of *Cat on a Hot Tin Roof*, and the time had arrived for the first rehearsal. The cast had been contracted to work for two and a half weeks in rehearsal until the play opened for a preview performance on a Thursday and the big opening night on a Friday. Rehearsals were scheduled for Tuesday through Sunday, seven hours a day for two weeks. The final week, technical rehearsals on the set were Tuesday and Wednesday for seven hours, with the preview the next night. The schedule was fairly typical. This is the way a theatrical project gets put together.

In their private time, actors were expected to memorize their lines, do their character homework, and practice on their own. For two and a half weeks they would be completely immersed in the world of the play.

It does not sound that uncommon. When a business project is in its final phases before roll-out, designers are often working long hours, immersed in the final details of the project. The play, as a matter of fact, once it is in rehearsal, is in its final phases. The director has been planning for months. The set, sound, lighting, and costume designers have been working with the director for months to ensure that the creative things they bring to the table all work well together. They all work to meet the overall vision of the director, or, at least, they work together and the director mediates if their ideas conflict. The casting is done weeks, if not months, before the first rehearsal. The director spends hours at the library studying the time period of the play, trying to understand why people behaved the way they did at the time. Marketing designs have been made and implemented, tickets have been sold, the media has been alerted, and the bookkeeper has it all accounted for. In short, just like a project on Wall Street or Main Street, the play takes months, if not years, to get to roll-out. With the play, however, there cannot be a delay if everything does not go just right. Opening night is opening night. The play will open. So, like in business, as difficult as it is to get all those creative pieces to come together at exactly the same moment when we want the project to be completed, the play faces the same challenge. However, the play has no leeway.

So the need to be effective as a leader is not only important for a play, it is essential. In Chapter 3, the three types of leaders identified as most essential in theater were the communicative leader, consensus leader, and collaborative leader. Of those three, the communicative leader is difficult to dissect in the metaphor of creating a play because we have identified the stage manager as the primary source of communication. The function of communication is so essential in the play-making process that one person is hired solely to facilitate and ensure excellent internal communication both to and from the leader, the director. You may think that because your company has a communications director you also have this covered, but that is not necessarily so. The stage manager has no interaction with the external world. They do not deal with buyers or vendors. They do not interact with the media. They have no knowledge of the customer. In fact, the stage manager does not even deal with most of the people in a theater company's day-to-day operations. The stage manager is simply the communications facilitator for the people working on creating the innovation, the product, the play. The stage manager is so essential to the process of creation that one wonders why the position is not more often recreated in other creative industries. Does your team have one? Does your department have one?

Because the stage manager handles so much of the communication process, we can spend a little time focusing on the other two essential types of leaders in theater: the consensus leader and collaborative leader. In order for the rehearsal process to work, there are two other leadership types that come into play. Of the remaining five, charismatic, inspirational, personable, instrumental, and trusting, three are key to a good rehearsal process: personable, instrumental, and trusting.

Collaboration as a Means for Growth and Improvement

The idea behind collaboration is really interesting. Because if you think about what the word means, it implies that people are working together. So to suggest that someone is a collaborative leader is a bit of an oxymoron. How do you work together if you are the formal authority, wielding some sort of power over those with whom you are collaborating? It would be a collaboration of equals where one is more equal than the others. Collaboration is difficult enough, because it requires a certain amount of sharing, cajoling, persuasion, personality skills, maybe some technical expertise, and a whole lot of luck and chemistry mixed in to be effective.[2]

In the rehearsal of a play the director is, in essence, the formal authority. They have casting rights, which means they make hiring and firing decisions. The director, however, doesn't really have the autonomy to do that as they please. There is actually a business person, above the creative process, who makes the hiring and firing decisions, occasionally on the recommendation of the director. That person is the producer. In fact, directors rarely fire anyone. Nor do they control salaries, provide any punitive actions for inappropriate work behavior, or give any tangible rewards for work well

done. If the director has any carrots or sticks to provide at all, it is in the form of intrinsic rewards. Positive comments and attaboys are about the extent of what a director can do. In this regard, while the director has some formal authority, the director is more a part of the creative process with a specific function. Their function may have to do with coordinating everyone else's functions, but it is not to be the boss. The best directors are the ones who have demonstrated, time and again, that they are able to share, cajole, and persuade a team to do all the right things at the right time in the right direction (hence the word) so that the play is a hit.

Everett Galveston was in a more unique position. As the CEO of Nirvana Rep, and also a frequent director of productions there, he had both the position of formal authority and the role of collaborative creator. In order to do both successfully, Galveston had to walk a very fine line. He had worked his way up at Nirvana, so those who knew him knew that he was a collaborator first and an administrator second. But for those who were new to the company, the lines were not quite so clear.

In one instance, Galveston was faced with a difficult decision. He was rehearsing an adaptation of *It's a Wonderful Life,* and the man playing Uncle Billy just wasn't fitting in. Uncle Billy is a bit simple, but no matter how Galveston communicated with the actor, he simply played Uncle Billy as a drunk, or at least the performance came off that way. Galveston was a very patient man and spent countless hours trying to help the actor find a character that didn't appear drunk, but the harder Galveston tried to help, the more the actor dug in his heels and played that character even drunker. Finally, Galveston knew he could do no more, and the production was in trouble without resolution. So he spoke to the business manager at Nirvana Rep and asked, "What do you think I should do?"

"You know I really like Dale," she said, referring to the actor. "He's always done good work here before."

"Yes," said Galveston, "and I'm sure that this current challenge has to do with his illness."

This was the worst part of the story. Dale was in the early stages of a terminal disease. He was expected to live only about a year.

"Everett," said the business manager in a gentle tone, "I would never want to hurt Dale, or kick him when he's down, but you've made it clear that he has to try to reach for a different character. Is he doing that?"

"That's just it. We've tried and tried, and we aren't getting there."

Note that Galveston referred to the work being done as work "we" are doing, not work "he" was doing.

"Then," said the business manager, "his understudy is going to have to have time in full rehearsal, because he will have to take on the role. Dale is not going to be able to do it."

Galveston grimaced. "I can't fire him."

"You've let actors go before."

"Not when I was directing them. Only as a producer. I can't have other actors thinking that the axe drops out of my hand. We have to work together. I can't have them afraid to displease me or they'll never be willing to take the risks they need to in order to be successful."

"Okay," said the business manager, "I'll sit in on this afternoon's rehearsal as producer-of-record, since you are presently director, and I will make the decision whether he has to be let go or not, and if he does, I will do it."

"That may work."

It did work, and Dale was let go, but not before he acknowledged that it was the right thing for the production. He was not upset about leaving the play. He knew what he was doing was not the right fit. And in the end, he bought tickets to every single performance.

Collaboration is a tremendous asset in an organizational setting, and by organizational I mean any group of people organized together for a mutual purpose. Collaboration allows ideas, thoughts, and creative momentum to build. One person has a thought, and that thought is allowed not only to flourish, but to grow and become something bigger and better because it is being developed in collaboration with others.[3] Consider the actor who wants to play Uncle Billy like a happy drunk. In collaboration with other actors and the director, the actor may *find* Uncle Billy as a man who is always happy like a happy drunk, but he actually isn't drunk.

In some cases, the idea is improved upon, and the original idea falls by the wayside for the improvement. Now consider that the actor chooses to play Uncle Billy as a happy drunk, but someone suggests that there are moments of terrible frustration that would irritate a drunk more than someone who was sober. The drunk might become very frustrated with minute details, and focus too hard on them. Other times, the drunk may be perfectly happy and not notice huge events. Now, take away the idea of being drunk altogether. Uncle Billy becomes a bit ADD, but not drunk at all. The original idea fell by the wayside for the improvements it was given. These things happen in collaboration, and they occur over a period of time, not all at once. Each step is allowed to play itself out, and then someone, often the director, nudges a move forward in a slightly different direction. The final result is a collaborative work of art.[4]

Respect

One of the most powerful aspects of creating a theatrical production is that there is a respect amongst all the players. Director, designers, construction crews, actors, costumers, and the like, virtually everyone on the team, has respect for each other and their work. It is this level of respect that nurtures all those creative people and allows them to work well together toward a common creative goal. However, developing and having that respect requires a great deal of trust.

It is far easier to consider the failings of disrespect, and to consider how one avoids them, than it is to determine how, exactly, one develops respect. But the former leads to the latter, so we shall start with disrespect. We know that there is a lack of respect from staff to management when management does not communicate effectively or appropriately. Likewise, disrespect occurs when decisions are made that do not consider how they will affect staff. As a result, staff pulls away from participation in global organizational goals.[5]

A number of factors play into respect in an organization, and they have to do with how we look at our organization. The first of those is organizational justice. We consider organizational justice when we determine how we feel about fairness within an organization. Is management fair in its dealings with people? Organizational justice goes hand-in-hand with interactional justice. Interactional justice has to do with how people determine they are treating each other on a person-to-person basis.[6] Interactional justice can be further divided into two parts: interpersonal justice, which has to do with how people feel they are being considered and respected, and informational justice, where people consider how they are being involved in the flow of information.[7] When people feel disregarded, or when they feel that they have not been heard, their thoughts are not considered, or when they feel ignored or marginalized, they respond by investing less in work and in the creative process. Interpersonal justice, that need for respect from individuals, is a key in creating a piece of successful theater work. The players all respect one another, pay attention to each other, and consider their thoughts and ideas seriously.[8]

During the rehearsal of a play, actors feel comfortable holding each other accountable for their actions. What one actor does will have bearing on another, and they respect each other to work out the challenges that may arise. Each actor has certain demands for what their character must do, and each actor respects the decision-making process of the others.

In the process of rehearsing *Spiderman: Turn Off the Dark,* Julie Taymor, the director, was reported to have very big ambitions. The musical cost $70 million to put on stage, and Taymor's vision was implemented as she saw it. The producers, knowing that their $70 million was in a very precarious place, also knew that they had to respect the autonomy that their director required. That respect for her, the granting of authority to make her own decisions and decide her own artistic course, was essential for the development of the creative product.[9] But when her artistic team confronted her with some ideas for improving the musical, as it appeared to be an out-of-control freight train, rather than listen and consider the ideas, she dismissed them.[10] Because she chose to neglect or not consider the ideas of her collaborators, the creative process buckled. Shortly thereafter, Taymor was released from the project and replaced.

But respect is not simply about honoring someone's autonomy and authority. It is also about supporting their independent choices even when you believe they are the wrong choices.[11] There is a certain amount of paternalism involved in the fact that we must choose when to step in to protect

someone from consequences that could be disastrous or cause them grave harm, and when we need to respect their autonomy and authority. We are challenged, as leaders of creative people, by balancing the need to allow creativity to flourish with the need to ensure success.[9] This is the basic dichotomy the leader of creative minds must face.

We described the personable leader as "the leader who has genuine concern about individuals or groups of subordinates. This leader exhibits genuine respect for constituents." When Brian Artsman was developing a new season of plays, his marketing director presented a plan to promote the season in total. The play selections were somewhat reserved and dramatic, but the marketing campaign looked almost modern, with sleek lines and bold colors, and the text emphasized wit and humor in the descriptions of the plays. The tag line for the promotion was about theater being fun. Artsman studied the materials for a long time, but rather than simply saying they needed to be changed, he asked a question.

"The plays are dramatic, but the materials are lighthearted. I'm curious about how that works in a marketing sense. I wouldn't have thought to promote the season this way."

"Ah," said the marketing director, "very astute. We have balanced the plays, which are largely well known, with a sense of whimsy to indicate that this is not a depressing season, just a season of great art. Our research indicates that almost 97 percent of the people who are likely buyers already know what the plays are about. So our goal is to enrich that understanding, not to reiterate it."

"But," said Artsman, "isn't this giving a false sense that we will produce funny versions of the plays?"

"From an insider's perspective it might appear that way. To the average theatergoer what we find is that the modern visuals, the whimsical text, and the known play titles all cause the market to gain a sense that we have depth of presentation. Is that a fair statement about our productions?"

"Of course it is," said Artsman. "This makes perfect sense. I'm glad I learned a bit more about theater marketing today."

This exchange not only demonstrated a certain amount of respect for the work the marketing director was doing, but it showed a genuine concern for both the company and the marketing director's need for autonomy. Brian Artsman easily demonstrated that he was a personable leader.

John Precinski did not. In a similar exchange with a marketing staff member, Precinski saw an advertising board for a new style of dashboard the company was developing and said, "You need to make our company name much bigger, and get rid of the hand touching the dashboard in the picture." He then walked away.

The staff member quietly grumbled that the promotional material was going to vendors who knew the company, and that the piece was not designed to promote Shangri-La Automotive, but to introduce vendors to the new dashboard concept. Making the company name larger would diminish the message and clutter the piece. It was advertising 101. The hand, a symbol of introduction, was key to the message. Precinski was uninterested in

facts or time-tested theory or data. Precinski made it clear, in one comment, that he did not respect what the staff knew or did. Precinski announced in twenty-one words that he believed his opinion was more valuable than this staff member's. *Respect is a two-way street. It is best earned when it is shown to others.* Precinski lost a great deal of credibility in this exchange, and after a handful of exchanges like these with several people in the company, he diminished his capacity considerably.

Trust

There has been a great deal of study by academics about trust and how it is involved in the leader-subordinate relationship. Trust has been dissected and modeled, expanded and contracted, evaluated and interpreted. It has most often been related to something called leader-member exchange, which theorizes about how leaders develop relationships with different subordinates.[12] The theory behind leader-member exchange is that a leader and a subordinate each bring different contributions to the relationship that are beneficial to the other party or the relationship in general. Over time, it is expected that the relationship between the two people will reach a level of equilibrium, where each is contributing like amounts to the relationship.[13] Without some balance between the two parties, as you can imagine, relationships suffer and fall apart. The person contributing more has a tendency to withdraw to try to achieve some better sense of equilibrium.

What we do know is that subordinates who are closer to a leader, or are part of an inner circle, are there because they are granted more authority and control of negotiations. This occurs because those who are closer to a leader develop that closeness through a mutual support and openness, and the relationships are founded in trust.[14] We also know that when there is a strong leader-member exchange relationship, it usually goes beyond the boundaries of the regular workload in a single work day. In other words, when there is a strong relationship, the subordinate has a tendency to invest more into both work and personal relationships with the leader, and when there is a weak leader-member exchange relationship, the subordinate invests less. It is not surprising, since the investment in trust requires some level of risk, of making oneself vulnerable to another, and that is rewarded with an exchange of extra effort.[15]

But unlike in the studies of leader-member exchange, trust, as it turns out, is a little different. In leader-member exchange there exists, or attempts to exist, and equilibrium in what each party brings to the table. When it comes to trust, the characteristic works on a continuum, and levels of trust between two players can differ drastically. That, however, is not so easy to understand in the real world, because there is no test that can measure levels of trust.[16] It is intuitive that we trust someone more or less than they may trust us, but we cannot take a test to determine levels. My

scoring on that test, and my perception of trust, could be entirely different from someone else's. We have to take at their word what a person says about how much they do or do not trust another.

There are really three factors that lead to one developing a sense of trust. All three of these, in some combination and with some level of strength in the equation, contribute to the notion of trust. The first is ability or competency. In theater, this would be the demonstrated ability of the actor to perform a role or of a designer to create designs. When Arthur Fine slowly let the details of his new vision for Shangri-La Automotive out, he made clear that he did not trust his staff. But what is important to note is that staff were content experts in the company. They knew how it ran, what it did, and how to make all that happen. Arthur Fine disregarded their ability to develop a vision. He disregarded their competency to the do the job in the right way.

When Brian Artsman questioned a scenic designer about color choice, and the designer noted he felt he was on the right path, Artsman recognized that the scenic designer was the expert in design. Artsman accepted the ability of the designer and, hence, gave him a certain level of trust. Had Artsman needed a good haircut, it is doubtful that he would have asked the scenic designer for advice. The designer's ability or content expertise is not in hairstyling (or likely is not, anyway), so the level of trust that Artsman would have had in this area would have been considerably lower.

In business, one of the ways we establish trust through ability is by doing good work, obviously. The trust level is strengthened by constant feedback. When a subordinate does good work, we provide a performance evaluation that says so.[17] The more we provide positive performance feedback, the greater the notion that ability is strong. When ability is strong, trust is strengthened. What this means is that if people do good work, the relationship with the leader is strengthened. *If your employee is not doing good work, it is your responsibility not to provide punitive or corrective measures to get them to shape up, as John Precinski was so fond of doing, but to provide the support and guidance needed to help make them successful.*

Another way we develop trust is through benevolence. Think of benevolence as a sort of caring for another person. How much does a subordinate really want to do something good, kind, or caring for you? It is very likely that you know people whom you like a great deal, and as a result, you trust them more. There are also people you like less, and consequently, your trust level for them is lower. This is not to say that there is a perfect one-to-one correlation between benevolence and trust. It is perfectly likely that you like someone but do not trust them. It is also likely that you can dislike someone for any number of reasons, but still trust them. Regardless of all that, if you like someone, there is a greater likelihood that you will trust them. This is important not only for developing a certain level of trust with your subordinates (if they like you, they are more likely to trust you), but for you as well. How can you trust your subordinates unless you like them?

The third thing that goes into trust is integrity. This is a bit of a no-brainer, but it is important to consider. Integrity is a combination of behaviors that demonstrate a person will stick to appropriate principles and follow through with what those principles dictate. This area is often challenging for people, because they are challenged by competing people and influences, which make it difficult to determine a best course of action.

On a number of occasions Steve Winston was faced with a designer who wanted to invest more money in plastic coverings and a designer who wanted to invest more money in leather coverings. Winston, who knew that trusting the ability of his designers was essential, shared his own concerns about investing in anything. When the battle raged on between the two designers, rather than sticking to his own principle of not investing in anything, Winston would hear the arguments and try to mediate a solution. The final solution was that an equal amount would be invested in both coverings, yielding little creative result, because there was not a substantial investment in either one. As a result, neither designer trusted Winston. He could have retained trust if he would have stuck to the principle that it was a bad time to make a strong investment in anything. He could have said that while he had always believed this was a poor time to invest, the research was indicating to him that it was time to invest in one covering or the other. What he did, instead, was mediate like a father. When a father tells you what you can and cannot do, or doles out hugs and kisses in equal proportions, you feel like a child. Those two designers did not trust Winston, because they felt like children.

One thing that happens in theater that we do not often see in business is that because a cast and crew are suddenly put together and asked to be creative in a very short period, under certain levels of duress, trust develops very quickly. Temporary groups have a tendency to develop trust quickly.[18] That trust is usually strong until some sort of betrayal happens, and then the trust relationship is looked at again by the participants. In theater, since the period for developing a play is short, comparatively, trust strengthens the creative process. Can you create short, temporary work groups who are thrust together to develop a creative project? Can your project be separated into parts so that each part has a finite period in which work will take place?

Encouraging Creative Thinking

There are a myriad number of techniques that encourage creative thinking. In fact, many of those airport books have all sorts of games and tricks and techniques you can do to coax creativity out of people. That seems a little counterintuitive, does it not? Creativity is something that should ooze from the pores of creative people. Creativity should be unstoppable if you are prone to creating. There should be no need to urge someone to be creative or to try to coax them or guide them into their creative space. Certainly all creative people suffer moments of disillusion, when they are not able to create as quickly or efficiently as they normally do, but Picasso painted

how many paintings and Mozart composed how many symphonies? Stephen King wrote how many novels? Writer's block may hit once in a while, but creative people are ultimately prolific with their creativity. Or are they?

As it turns out, Stephen King does suffer from writer's block, and not only that, there are days when he may not be able to write a single good word. But King offers this advice to would-be writers, and even seasoned ones, who struggle to put a good sentence on the page (or onto the screen, more precisely): write anyway.[19] It may seem a little odd, but what King is suggesting is that you have the tools necessary to write. You have the computer. You have the workspace. You have the ideas, and the skills to put one word after the other to form a string of appropriate sentences. Certainly every idea that rushes out of your brain through your fingertips and into the computer will not be a gem. Every word, every sentence, cannot be spectacular. But if you sit and try to hone each minuscule detail into perfection, you will never reach the two most important words: The End. So instead, King proposes that by using the tools you have been given, you can create a framework within which you can work toward perfection. If the pages you write on the day you have "writer's block" really are as horrible as you think they are when you commit them to electronic memory, well, go back and revise them when you go back and revise everything. Hone them at that point. Make them as perfect as you want them to be. You will have gotten the framework down, and the perfecting will be that much easier.

The interesting thing about this idea is that by putting those words down the first time, as imperfect as they may be, you are creating a tool for yourself to use to perfect them later. The entire process is hierarchical. You acquire certain tools which you use to create more tools, say an outline, which you use to create more tools, say a first draft, which you use to make more tools, say a final draft. When you think about it this way, creativity is really more linear than it seems. Each piece may be in and of itself nonlinear, but the process does have a beginning and an end and some benchmarks in the middle.

Everett Galveston, the second CEO of Nirvana Repertory, was fond of asking people for their opinions on certain topics. He would consider an idea someone had, and then give different members of the staff different pieces of the idea to focus on. Each would get a piece that would be most appropriate to their expertise: that area where they had the greatest tools in their toolkit. If the idea had to do with presenting a certain play, Galveston would ask a scenic designer to consider how the period might relate to the Detroit community where Nirvana Rep performed. He might ask the marketing director to determine relevance to the market, and so on. Each person had a piece of the puzzle to bring back to the table. What Galveston was looking to do was to see if the idea would have enough traction with the various players that it could be made to stick. They had the tools to get started, and he wanted to give them an opportunity to be creative and see if they could develop more tools that the entire team could use to create a play.

There are really two ways to encourage creative thinking. One is to present something related and allow people to consider it in relation to the problem. The other is to present unrelated things and equate them to the problem.[20] The bottom line about creativity is that it starts with relationships. How does this compare to that? How does this *not* compare to that? How do those comparisons measure up? How can those comparisons be altered to change the outcomes? If we can't find an "internal solution" to this problem is there an "external solution" that anyone can think of?

There are some basic guidelines about creativity that matter as much in the theater as they do in business. At least one of these guidelines has to exist in order for the process to be creative, and as you read the list, you will see that often all of them exist. The problem being solved, whether it is the creation of a new play, the development of a new steering wheel, or the generation of an entirely new electronic widget, has to have some new, innovative, or novel solution. The idea has to be something new, or at least a change or outright dismissal of something that exists. The work of developing something creative is not simply an inspiration that pops out of the head. It requires "perspiration," as Edison put it. It requires effort and intensity. Lastly, solving the problem is also related to defining the problem. In the process of creativity, we think we know what the end result will be until we delve into the problem, and then we learn all sorts of new things about the problem.[21]

A famous playwright once said that he meticulously plots out each moment of his script from beginning to end. He knows just who will enter a room, what issues will be addressed, how the characters will behave and respond to each other, and when they will exit the room. He details this in outline form before he begins to write. Every single time he sits down to write a new play, though, at some point, as he is typing away, he suddenly writes, "So and so enters," when that was never in his outline. With that, he simply lets his brain and fingers go free so that he can then determine why so and so had to enter at all. But the playwright is convinced that if he suddenly felt a need to write it, there was a piece of the puzzle he didn't understand when he sat down to write his outline.

Creativity is only challenging to some because it requires us to change the way we think. That does sound complicated, does it not? Actually, what it means is that we all have preconceived notions about the way the world works, about how problems are solved, and how things are resolved. In order to be creative, a person must, to some extent, let those preconceived notions go. It requires a change of mindset. It requires a paradigm shift.[22] But achieving that can be uncomfortable, especially if others in the group are able to make that shift faster. A paradigm is a jointly understood way of seeing the world, so when we ask people to see the world a different way, jointly, you can see why there might be challenges. That is why all those creativity-engaging activities exist—so people can find comfortable ways to get there.

In theater rehearsal, directors do many different types of improvisational exercises. They ask the actors to play the scene without saying a word, but trying to get the message across so that the actors recognize the value of their bodies in communicating. They ask actors to improvise the scene as if they were very happy, even though the scene calls for melancholy, and to make up dialogue that would be appropriate to happiness so the actors can feel different levels of emotion. There was the actor who wanted to play a scene very angry. It had its imprint. All of these things are ways to try out new ideas and allow the group to see them, feel them, experience them, discard those that are not effective, and capitalize on those that are effective to create the best play. The same type of creative processes occur in any creative endeavor.

Take brainstorming, for example, which is the most common of the creative techniques. Brainstorming actually doesn't ask people to shift paradigms at all. Instead, it suggests we preserve our current paradigm, though we may add to it. In brainstorming, the creativity is limited to developing a large amount of ideas, good or not, in the hopes that one or more of the large number will actually be a good idea. In the process, people hear one idea and develop their own that improves on the one they have heard. It is a series of random ideas that are all shared in the same room, and eventually, they are whittled and honed into one or a handful of solutions.

One way that creative types can be asked to shift their thinking is to ask them to consider something from completely "outside the box" and then compare it to their world, or *their box*. Steven Winston once asked a group of engineers who were working on a dashboard control system to consider how the buttons on a microwave oven worked. He suggested that it might be a good idea to consider placement, special feature buttons, ease, and the like for the user of the oven. He explained that this was not meant to suggest that an automotive dashboard was anything as simple or trivial as a microwave oven, but that consumers were accustomed to using a microwave oven on a daily basis, and those engineers had determined reasons to design the buttons the way they did. Winston's engineers spent hours in appliance stores trying out all sorts of microwaves, and ultimately, they used some of the ideas from those microwaves to develop an entirely new dashboard control system. What Winston was doing was encouraging creative problem solving, but the tools he gave his engineers were stimuli that were unrelated to the problem.[23] He gave them a different box outside of which to think. Winston provided the tools necessary for success. In this regard, Winston demonstrated himself as an instrumental leader.

These types of techniques, which force people to make connections they otherwise wouldn't have made, such as improvising happy though the script says otherwise, imagining a microwave though you are working on a car, all cause people to stretch their belief systems.[24]

One of the things that happens in a rehearsal room is that the director makes it clear, both by her words and her actions, that the rehearsal room is a safe environment. No one will be judged by anything they do. No one is expected to do their work in any specific way. There are no expectations

and there is always comfort. If the work gets too challenging, and people feel threatened in some manner, the creative work ceases. In the same way, stretching your belief system can cause grief. It is important for the instrumental leader to be clear about expectations, to reward successes with positive feedback, and to make certain that if someone feels unsafe emotionally, they are not forced to proceed.

Later we will discuss some exercises that can be done to help a creative team move past issues that challenge it. But these are difficult challenges, when a leader has to break a mindset or paradigm in order to help the group move forward. Because in order to get a group to move completely beyond a mindset, the leader must help them to, both individually and as a group, adapt. Adaptation, in terms of evolution, takes many, many generations of a species. In terms of a business cohort, the process has to be sped up, and it is the job of the leader to see that it happens in a safe, acceptable fashion for his constituents. It is a challenging process, but it is achievable.[25]

No matter how specific the need for problem solving is, creative people require a leader who will provide the tools necessary to achieve results. This means the leader must gauge a situation, balance differing needs of individuals, and be willing to guide, coach, and mentor them in the same direction at different paces. The instrumental leader provides the resources.

The Development of Consensus

John Precinski was fond of telling people that consensus was unachievable, but that a democratic majority could adequately solve problems. There is certainly some truth to the fact that politicians seem to have difficulty ever reaching consensus. However, politicians have a huge layer of politics that crushes all opportunity to actually work together toward a common good. Consensus seems extremely unlikely when politics dominate the agenda.

In business, politics play a role, and often a key role, in how people, including creative people, work together. Those political battles and struggles have a great bearing on how decisions are made, and it is, indeed, those politics that make consensus very difficult. But as we will later see, politics in the work environment are generally part of a hidden agenda, and driving that agenda to the surface often neutralizes it long enough for a group to work toward and achieve consensus. It is the job of a good, strong consensus leader to facilitate the commitment to a plan, and to develop the buy-in for that. In order to do so, a consensus leader has to neutralize politics and other hidden issues that can make working together successfully impossible.[26]

Remember the story of Everett Galveston at Nirvana Rep, who had passion for modern theater? He wanted to introduce modern theater to the company, so when he came on board he began extolling the virtues of modern theater. He did not present a new vision for the company that included modern theater. Nor did he contrive to get his staff to lean toward modern theater. He simply put the idea on the table through virtue of his passion for it, and made certain that the idea remained on the table. Eventually,

the staff picked up on the idea, on their own, and developed it into a vision which they reached by consensus. *Consensus cannot be reached when someone tells you it must be so. It is reached when passionate people get together and decide to work together to find solutions they can all agree upon.*

The global postmodern society is vastly different from the industrialized modern world of the last century. The information superhighway has leveled the playing field globally and has altered how we communicate. It has even affected how we think, now preferring to gather information in small Twitter chunks and headlines, blurbs, and sound bites. The ramifications of these changes has driven a desire, née a need, for consensus on a more frequent basis. There are simply too many other avenues to pursue if consensus is not reached. Changing technology, and hence, changing social networks, drives our need for consensus, occasionally at a swift pace.[27] Globalization has placed a great emphasis on the need for collaborative dialogue that results in consensus. Polarization of values of views, both in the political spectrum and the public eye, as well as the diversification of power worldwide, all put a great stress on businesses and the public to achieve consensus. In the theater, on opening night, there is rarely anything but consensus about the production. So how do the players get there?

Well, first of all, trying to achieve consensus is not the magical cure for everything. In fact, there are many instances where trying to achieve consensus would be foolhardy. The world of political governance is a prime example. John Precinski was right in the sense that achieving consensus is difficult. But he was wrong in suggesting that it was not possible. It is possible, and in many instances it is important and necessary, but it requires a leader with some ability to help his team get there. An effective leader always lets his or her staff know they are looking for the "best ideas," not just agreement with their ideas.

Consensus building works when people are not finding solutions to their liking on their own. This does not mean that when John Precinski dictated a solution, he was satisfied. Because when he did so, he dissatisfied many others. It means that there is a critical mass of dissatisfaction in solution-finding independently. But this also means that there must be a desire to find a solution. In other words, there must be some level of agreement that a problem exists. Sometimes, it is the consensus leader's job to point out that a problem exists. The savvy leader doesn't call it a problem; he simply puts an idea of a potential problem on the table as Everett Galveston did with modern theater. So we know that individuals (or perhaps small groups of individuals) are not finding good solutions, but consensus building also only works when other methods of finding solutions have failed. Building consensus is difficult, challenging, and time consuming. It is not for the faint of heart. As well, consensus building only works when there is some degree of consternation, where people have values that differ, or there is a controversy about how to understand certain issues. People also have to be invested enough to participate in consensus building. Participants have to have something that they can contribute to the conversation as well as something they can gain by being part of a dialogue. They have to have a good, solid,

defined reason why their participation in finding a solution, why finding a solution at all, is important, if not imperative. In addition, the process requires that everyone who has a vested interest in the problem and its solution are included in a meaningful and substantive way, not by force or coercion, but because they meet the criteria we have just stated. And the process has to have the possibility of having real bearing and effect on the real world when it is completed.

Additionally, consensus building requires that those who are participating in it can set their own rules of engagement. They have to be able to define how they will work together, what the agenda will be, how they will make decisions, and so forth.[28] Everyone has to be heard and respected, and the process has to be driven by the group, not by a formal authority. The formal authority can serve as a neutral facilitator, and a facilitator is essential for success, but that person cannot define the rules for the process. All information regarding the problem and potential solutions has to be open and available to everyone, and every concern has to be explored before consensus is reached.

Besides simply reaching a decision that is agreed to by mutual consent, consensus building has a number of important outcomes. During the process of consensus building, participants learn how to change beyond the group that is participating; there is a development of capital, both social and political; participants develop shared understandings for one another and about the information they have; participants develop a sense for what a high-quality agreement is, and why we work toward them; participants have for themselves and observe in others a change in attitude as well as in actions and behaviors toward and around one another; and participants learn about corporate flexibility and institutional networks.[29]

The process of consensus building always starts by assessing what conflicts exist amongst the participants, who should represent all stakeholders, and their issues relevant to the problem. In a theatrical rehearsal, the first meeting is often framed by a reading of the script followed by a discussion of what everyone understands about it. Different perspectives are shared from each viewpoint. In the rehearsal process, there is a clear understanding that everyone has a vested and shared interest in seeing the production achieve fruition. Everyone is there because they *want* to be there, and everyone recognizes that each other person in the room brings something to the discussion that is unique, valuable, and has to be part of the final solution, the production. Discussing similar issues in a consensus-building process is essential, and it is where a strong consensus leader can be a practical guide.

The consensus leader makes certain that everyone who has something to say is heard, and also makes certain that all information germane to the topic is available to everyone. This ensures that both, or all, sides of a situation have the appropriate amount of information to support them. The consensus leader also helps the group to find ways out of impasses by seeking out discussions that are out of the norm and outside the box. This helps participants to learn from each other, see different ways of examining the problem, and tell stories that are pertinent to them and to the problem.

Just like the improvisational stories that actors use to dissect and then build their play, consensus-building groups tell stories about their lives that detail how the issue is pertinent to them. They tell stories about what would happen if the problem is not resolved. They tell stories about what will happen to others if this or that solution is implemented. Eventually, they use all the stories to collectively build a new story that solves the problem.[30] The process is, ultimately, exactly like telling the final story of the play, except in the case of the play, we have a script that we think tells us all we need to know. It does not. It is only a guide. The consensus leader is the script. The consensus leader is that guide.

1. Fiedler, F.E., *Validation and extension of the contingency model of leadership effectiveness: A review of empirical findings.* Psychological bulletin, 1971. **76**(2): p. 128-148.
2. Linden, R., *The discipline of collaboration.* Leader to Leader, 2003. **2003**(29): p. 41-47.
3. Beyerlein, M.M., *Beyond teams: building the collaborative organization.* The collaborative work systems series. 2003, San Francisco: Jossey-Bass/Pfeiffer.
4. Austin, R.D. and L. Devin, *Artful making: what managers need to know about how artists work.* Financial Times Prentice Hall. 2003, Upper Saddle River, NJ: Financial Times/Prentice Hall.
5. Laschinger, H.K.S. and J. Finegan, *Using empowerment to build trust and respect in the workplace: A strategy for addressing the nursing shortage.* Nursing Economics, 2005. **23**(1): p. 6-13.
6. Lewicki, R.J., B.H. Sheppard, and M.H. Bazerman, eds. *Research on negotiation in organizations.* 1986, JAI Press: Greenwich, Conn.
7. Cropanzano, R., *Justice in the workplace.* Series in applied psychology. 1993, Hillsdale, N.J.: L. Erlbaum Associates.
8. Darwall, S.L., *The second-person standpoint: morality, respect, and accountability.* 2006, Cambridge, Mass.: Harvard University Press.
9. Darwall, S., *Sentiment, care and respect.* Theory and Research in Education, 2010. **8**(2): p. 153-162.
10. Healy, P., *Superstars never guessed the size of 'Spider-Man' challenges,* in *The New York Times.* 2011, New York Times Company: New York City.
11. Ebels-Duggan, K., *Against beneficence: A normative account of love.* Ethics, 2008. **119**(1): p. 142-170.
12. House, R.J., *The social scientific study of leadership: Quo vadis?* Journal of Management, 1997. **23**(3): p. 409-473.
13. Sparrowe, R.T. and R.C. Liden, *Process and structure in leader-member exchange.* The Academy of Management Review, 1997. **22**(2): p. 522.
14. Hunt, J.G., *Emerging Leadership Vistas.* International leadership symposia series v. 8. 1988, Lexington, Mass.: Lexington Books.
15. Rousseau, D.M., *Not so different after all: A cross-discipline view of trust.* The Academy of Management Review, 1998. **23**(3): p. 393.
16. Brower, H.H., F.D. Schoorman, and H.H. Tan, *A model of relational leadership: The integration of trust and leader-member exchange.* The Leadership Quarterly, 2000. **11**(2): p. 227-250.
17. Boyle, R., *The development of trust and mistrust in mixed-motive games.* Sociometry, 1970. **33**(2): p. 123.
18. Kramer, R.M. and T.R. Tyler, *Trust In Organizations: Frontiers of Theory and Research.* 1996, Thousand Oaks, Calif.: Sage Publications.
19. King, S., *On Writing: A Memoir of the Craft.* Scribner classics. 2000, New York: Scribner.
20. VanGundy, A.B., *Techniques of Structured Problem Solving.* 2nd ed. 1988, New York: Van Nostrand Reinhold Co.

21. Gruber, H.E. and University of Colorado (Boulder campus). Dept. of Psychology., *Contemporary Approaches to Creative Thinking: A Symposium Held at the University of Colorado*. The Atherton Press behavioral science series. 1962, New York,: Atherton Press.

22. De Bono, E., *Serious Creativity: Using the Power of Lateral Thinking to Create New Ideas*. 1st ed. 1992, New York, N.Y.: HarperBusiness.

23. McFadzean, E., L. Somersall, and A. Coker, *Creative problem solving using unrelated stimuli*. Journal of General Management, 1998. **24**: p. 36.

24. McFadzean, E., *Encouraging creative thinking*. Leadership & Organization Development Journal, 1999. **20**(7): p. 374-383.

25. Heifetz, R.A., A. Grashow, and M. Linsky, *The Practice of Adaptive Leadership: Tools and Tactics for Changing Your Organization and the World*. 2009, Boston, Mass.: Harvard Business Press.

26. Heifetz, R.A., *Leadership Without Easy Answers*. 1994, Cambridge, Mass.: Belknap Press of Harvard University Press.

27. Innes, J.E., *Consensus building: Clarifications for the critics*. Planning Theory, 2004. **3**(1): p. 5-20.

28. Susskind, L., S. McKearnan, and J. Thomas-Larmer, *The Consensus Building Handbook: A Comprehensive Guide to Reaching Agreement*. 1999, Thousand Oaks, Calif.: Sage Publications.

29. Connick, S. and J.E. Innes, *Outcomes of collaborative water policy making: Applying complexity thinking to evaluation*. Journal of Environmental Planning and Management, 2003. **46**(2): p. 177-197.

30. Forester, J., *The Deliberative Practitioner: Encouraging Participatory Planning Processes*. 1999, Cambridge, Mass.: MIT Press.

Chapter 6
Steps in the Creative Process

"Years and years ago, I read a great interview with Jam and Lewis, the R&B producers, in which they described what it was like to be members of Prince's band. They'd sit down, and Prince would tell them what he wanted them to play, and they'd explain that they couldn't—they weren't quick enough, or good enough. And Prince would push them and push them until they mastered it, and then just when they were feeling pleased with themselves for accomplishing something they didn't know they had the capacity for, he'd tell them the dance steps he needed to accompany the music. This story has stuck with me, I think, because it seems like an encapsulation of the very best and most exciting kind of creative process."

– Nick Hornby (The Polysyllabic Spree)

Politics

One of the most challenging issues a leader has to deal with is politics. For those in elected positions, politics are largely aired in public, sometimes by the person pursuing a particular agenda, but more often by his opponent, who wishes to call him out for his mindset. It is rare that someone uses the word "politics" without meaning it in a pejorative sense. Politics is not

something we revere, but something we tend to revile, because politics often get in the way of getting things done, especially when the something we want to get done is creative.

Politics exist in virtually every situation to some degree. In fact, politics are the hallmark of acting, because it is the actor's job to figure out what his or her character secretly wants or needs in every scene. The politics of the scene are the unspoken agenda issues. Sometimes we refer to this as the subtext, and it exists in every scene, for every character. Part of life is about knowing what your own subtext is, and trying to figure out what everyone else's subtext is. It is one of the keys to good negotiating: try to figure out what the other parties have to have, what they need to have, what they want to have, and what they are willing to give up. If you can figure out why people make the remarks they do, why they behave the way they do, and what they are hoping to achieve, you can be very successful. In fact, if everyone were simply to lay their cards on the table and be straightforward about those things, life would be much easier. However, we live in a world where the advantage is gained by winning. The more you win, the better the advantage. So no one is willing to lay their cards on the table, because there is no way to get more than simply what is required.

For those who are willing to work at it, it is possible to get better at perceiving what people have on their agendas. Oftentimes, in the creative environment, the biggest agenda issues are things that block the progress of work. They don't necessarily have to do with a particular topic, but they do make it impossible to achieve something together. *When people harbor issues, whether they are germane to a creative project, a need for change, a strategy, a communication, or any other interaction with others, regardless of the nature of the issues, real work cannot proceed until the issues have been resolved. Figuring out what the issues are is the hardest part of the equation. Resolving them is usually easy.*

John Precisnki was a man full of issues. Carl Jung could have written books about John Precinski. This is not to suggest that John Precinski did not want to excel, or that he did not want Shangri-La Automotive to be successful. He did want the company to be superior, he worked tirelessly to try to achieve superiority, and he was driven. Unfortunately, John Precinski was driving in the wrong direction. John Precinski's approach to leadership sounded like this:

"First of all, Shangri-La Automotive has to function democratically. Consensus is impossible, so we don't bother to reach for it, as that ends up being a waste of time, but if we have an important issue, the majority rules. Everyone will provide his or her thoughts on the topic, and then we vote. Because if the majority supports an issue, the long-term prospects of success for the issue, and for me as CEO, are good. Occasionally, I have to step in and make decisions without input from the staff. There are times when they don't have the necessary information to be informed enough to participate in the decision, or it is an issue which I know is pertinent to the company and the dissenters may scuttle it. That is my prerogative as CEO, and it is why I was hired: to make the tough decisions. Sometimes those decisions

don't make me friends. But I don't care. I am not here to make friends, I am here to get this company growing. Besides, being friends with the people you work with can be dangerous. It clouds the judgment. I prefer to keep an emotional distance from the people I do business with. Strictly professional. I greet people politely in the hallway, but I am not a touchy-feely person. In fact, I don't make a lot of friends, and that suits me just fine. But in business, no one is a friend. It just makes for better business. People have to be held accountable for their actions. If they screw up, you have to fire them. People who make friends don't like to do that.

"When there are issues with people, I don't take it lightly. I also don't want to hear about their problems. I want the work done, and I want it done right. The rest of it is their own problem. So I don't tolerate the whining and complaining. That's what gets in the way of good business. They had better leave that stuff at the door, because while I'm CEO, it will not be tolerated. It's not my job to be their mother, and no one else here should have to hear it either."

There is an awful lot going on there. John Precinski is not so unusual, either. He is a man who is dedicated to success, believes in keeping things organized and efficient, and runs a company without a lot of fuss and bother. There are many corporate executives who run a tight ship just like Precisnki. In fact, perhaps you are one of them. There are certainly a lot of good points Precinski makes in his treatise on leadership. Of course we know that, as it turns out, consensus is possible to achieve. It is not easy. But it is achievable. What it requires is a leader who can and will do the work and provide the resources required to achieve consensus. It requires a leader who understands why consensus is sometimes essential.

John Precinski frequently required those at a meeting who had not yet contributed to speak up and say what was on their mind. This usually resulted in several people being put on the spot and saying they agreed with what someone else had said. Sometimes those who had remained quiet were forced to say they did not have an opinion. In one instance, a person regularly put on the spot by Precinski simply stopped attending staff meetings. Precinski regarded this as that person's personal drama and refused to recognize it. He did not wish to play into her "little game," as he referred to it. Instead, he simply ignored the fact that she no longer attended staff meetings, and was satisfied that the punishment would be that she would have to live with whatever decisions were made without having any say on the matter.

We know that Precisnki was simply losing the thoughts and ideas of people who were not comfortable speaking at a crowded table. We know that he was alienating people on his staff. We know that rather than creating a decision-making process that was inclusive, under the guise of forced participation, Precinski was excluding a great deal of insight and participation. He required that people participate in the way he demanded or they were not welcome to participate at all, and he was fine with that.

There is an interesting notion about the majority ruling. Our democratic society was actually set up to protect the minority, not the majority. When one group has a majority, they do control decision-making. However, they must recognize, in a real and profound way, the minority and their wants and needs, because in our democracy the majority can just as easily slip into the minority. In the complex web of issues that make up a democracy, there are issues that would have one person as part of the minority and issues that would have them as part of the majority. Success of the process lies in the fact that there is respect for everyone in the decision-making process—true respect, not forced participation—because we will all be on the minority side any number of times. Precinski's love of the process lies in the fact that he can control the agenda of Shangri-La Automotive, bringing issues to the fore when he knows he is in the majority, and making decisions autonomously ("That is my prerogative as CEO, and it is why I was hired: to make the tough decisions") when he suspects he would be in the minority. What this means is that Precisnki had placed himself in a position where he could abuse power, be a dictator, or both.

Precinski noted that his success would lie in the fact that there was a majority support behind a decision. This was, presumably, because Precinski believed that decisions made by the majority would mean that he would always have a majority of the staff supporting him. He believed that because he allowed the majority to have control over issues (at least to the degree he determined they were capable of addressing issues) the majority would be supportive of him. The fallacy of this logic is that the make-up of the majority is always shifting. And even if the exact same people are the majority most of the time, people only need to be disrespected once by someone to lose faith. Eventually, everyone at Shangri-La Automotive was driven over by John Precinski. Eventually, they all wanted his head.

John Precinski recognized that sometimes there were decisions that he had to make in which the staff was not able to participate. This is true of any CEO. There is sensitive information that cannot be shared publicly, and the CEO must make a unilateral decision. Sometimes the CEO has to hear what everyone has to say, and for the sake of expedience (consensus takes a great deal of time) has to use that information to make the most informed decision possible. This is often how the President of the United States makes decisions. Sometimes a board of directors has made certain decisions the exclusive realm of the CEO. But John Precinski failed on a communication front. When decisions have to be made and the staff simply does not have the required information to participate in the decision-making process, it is his responsibility to provide that information to the staff. Precinski noted that especially when the decision was an essential one for the company and the information had not been shared, he would make decisions. However, when the decision is an essential one for the company, the company should be participating in the decision. In fact, when the decision is an essential one for the company, then one of the criteria for entering into the consensus-building process has been met.

Precinski also noted that when there was a possibility of dissenters scuttling a decision, he would make it. This comment is hardly veiled. It means that when the minority might exercise its right to speak, Precinski would prefer to make the decision. It is a statement that runs afoul of his support of democracy, because it is a statement in support of dictatorship. Precinski liked to hide his dictatorship in a cloak of democracy when it was convenient, but he was hardly involved in participatory governance.

His comments about staff participation in decision making also belie both a lack of trust and disrespect for the staff. He chose not to trust them both with certain information and with certain decisions. He disrespected them by choosing to keep the minority quiet. Certainly his comments that show his lack of care and concern about the problems, personal or professional, that staff members might have, further demonstrate his lack of respect.

Precinski is not a warm, fuzzy gentleman. He had professional relationships with the staff and the board of Shangri-La Automotive, he would show up at company social gatherings for brief periods of time, arriving late, saying little, and leaving early. He had no social interaction with anyone that was voluntary. He considered none of his business associates, including vendors and buyers, as friends. Nor did anyone consider him to be their friend. Precinski believed that maintaining a professional distance was essential for good business. When he was asked directly if he considered anyone he worked with to be a friend, he replied with a precise, "No."

The logic of Precinski's position about friends seems to make a certain amount of sense. Sometimes business decisions, especially personnel decisions, are difficult enough, and if they have to be made about friends, they are even more difficult. Separating friend from business colleague when one person is both to you is not only difficult, it is impossible. The most important lesson, however, about making friends with the people you work with and especially the people who work for you, seems to have been completely lost on Precinski. It is this lesson: *If the people who work for you are not your friends, then the best they are is indifferent and the worst they are, are enemies.* No leader will ever be successful long if everyone he works with is indifferent or an enemy. Even if those people are not working to undermine you, they are certainly not working to support you.

A bit more about people. It is true that employees must be held accountable for their actions. Precinski means that discipline must be meted out to correct unwanted behaviors. On this issue, there is a mindset that is missing, and it is likely missing because Precinski did not know how to be friendly. As a supervisor (manager, leader, or some other form of supervisor), part of your responsibility, in fact, a very large part, is to ensure that those you supervise are as successful as they can possibly be. That sounds simple enough, but it also means that when someone screws up, it is not your job to fire them, or straighten them out, or hold them accountable for their actions. It means that it is your responsibility to help them avoid failure in the future and assure success. If you have an employee who is always tardy, it is not your job to punish them. It is your job to help them find a class on time man-

agement so they can learn to be prompt and hence, successful. Of course, if you provide all the tools you possibly can to help them toward success, and they refuse to use the tools, then they are choosing to leave the company. You let them know that you are providing as much as you can, and if they do not apply those tools, they will have to go elsewhere. This is very different from Precinski's "If they screw up you have to fire them."

Precinski also felt that if people had their own problems, they should leave them at the door. There is logic in this school of thought as well. At business, people should focus on business. What we hear a lot about these days is the idea of work-life balance. Work-life balance is the notion that the two things have to have some sort of equilibrium in order for us to be successful at them.[1] If work is overwhelming, life is unfulfilling. The reason we work is so we can enjoy our lives. We do not have lives so that we can enjoy work. But if work is so demanding that it is detrimental to life, we are challenged. It happens on occasion, and we do what we can to regain equilibrium.

Notice that Precinski never mentions whether he is bothered if his employees take work stress home with them, though his remarks imply that he would not care one way or another. In fact, he should care. As a leader, it is his responsibility to make sure that his employees are successful, and part of that responsibility means making sure that there is a good work-life balance. Work should not be so overwhelming as to outbalance life, and when those rare moments happen, Precinski should know to step in and help an employee regain balance.

The same is true the other direction. When life presents challenging issues, rather than demanding that someone leave their issues at the door, Precinski needs to know how to ease work pressure until equilibrium can be restored. In reality, if you have a personal issue, you may be very good at hiding it, but you cannot make it go away, and you cannot simply forget about it for eight hours a day. It will affect what you do, even if you think it does not. A good leader spots these problems and provides what resources he can to ensure that an employee can be successful and have a good work-life balance.

Creative Process Steps

Sometimes employees, colleagues, or friends do not tell you they have issues. Sometimes a colleague simply becomes quite contrary with no explanation. Sometimes, with no perceivable change, results end up differently than they used to. Sometimes change is simply impossible and no one can figure out why. Sometimes we think things are improving when, in fact, nothing is really happening. The culprit, more often than not, is that there are issues that are hiding beneath the surface in one or more people, and those issues make working together effectively impossible, because they are blocking the real work.[2]

There are a number of phases that we all go through in the process of doing something creative. In terms of the word "creativity," we mean the process of ideas and actions that lead to the development of a novel, new, or adaptive result.[3] For about a century there has been a general acceptance of a four-stage process that is the course of creativity. The four stages are preparation, incubation, illumination, and verification.[4] In preparation, the problem is defined, or perhaps loosely defined, and its measure is analyzed and considered. In incubation no conscious work is done on the problem. In this phase of the creative process the subconscious works on the problem and makes associations and connections that may lead to solutions. In illumination, solutions from the subconscious now make their way into the conscious. In verification, the ideas are checked, considered, evaluated, and redefined if necessary. During the entire process, one can jump back to any earlier step and all around. Though the steps start in this order, they do not necessarily remain or parade from beginning to end in the order.[4]

There is actually a practical set of things that occur during these creative phases. The practical pillars do not necessarily align with any of the phases, but they do occur simultaneously during the phases of creativity. These practical pillars include: 1) The identification of real problems as well as artificial, superficial, or unrelated problems that can sidetrack work on the real problem; 2) Determining who the creative, collaborative players are and what roles they will play in the process; 3) Identifying individual blind spots that may require both understanding and improvement; 4) Determining how formal and informal authority will be used through the creative phases; 5) Finding a means for exercising leadership as a process rather than the work of one person "in charge"; and 6) Recognizing and clearing away hidden issues and noise.[5] These pillars can be driven by a practiced leader.

A Case Study

Peter Drucker is one of the best-known management gurus of all time. He said an awful lot in his seventy-plus years of studying management. This wise man once said, "The knowledge-based institution that most closely resembles a knowledge-based business is the symphony orchestra, in which some thirty different instruments play the same score together as a team."[6] Since the time that he first made this sort of observation, a number of researchers have looked at what makes a symphony conductor or a leader of creative workers unique.[7-10] It turns out that some of the best leaders are those who exercise leadership with creative people, because they have a greater capacity for the collaborative adjustments one has to make in the creative world.[11] These leaders also are more resilient in terms of lowering the defense mechanisms of those they work with.

An examination called the Defense Mechanism Test (DMT) has actually been used to see if there is a correlation between things like lowering defense mechanisms and strong leadership.[12] The DMT did suggest that lowering defense mechanisms like repression, regression, denial, projection,

etc., is a correlate to strong leadership. Excellent leaders have resilience and solid emotional development, though on the latter, there is some variance based on the specific industry such as construction workers,[13] education,[14] law enforcement,[15] and theater[16]. What seems to be true across the board is that as people mature, they become better leaders, presumably because they develop both greater resilience and a stronger grasp on their emotions.[11] The challenge, then, is how does one become a better leader if what it really takes is time to mature?

One thing that researchers have looked at is how theater directors, both young and old, do their work differently from businesspeople to see if there might be a clue there, and it turns out there are a few. Directors create a vision for a play by looking at individuals and details and character traits and the like, while businesspeople create a vision by examining broad markets.[17] Directors cast by looking at how all the players fit together. They do not have a list of criteria for work that the employee must best fit. Directors, as we have already noticed, do everything in a collaborative fashion, lowering defense mechanisms rather than doling out rewards and punishments to get the work done effectively. Lastly, directors, while they are working, focus on the moment they are working on, often giving actors the instruction to "stay in the moment," and businesspeople work on a linear path.[17] When you consider those distinctions, maybe there is something to the idea that leading people can be taught using lessons from the theater.

That course at Harvard is a real attempt at teaching leadership.[18] The premise behind it is threefold: 1) Leadership is different than authority. Just because you have been hired as the boss does not mean you are the leader, or that you are exercising leadership. Some leaders emerge from the rank and file. Some leaders work in the background. Some leaders assume authority. But having authority is not the same as leading. 2) Leadership is not about solving technical problems, it is about solving adaptive ones. Leadership is a process where things and/or people require change; usually substantial change. Finding answers is not leadership. Being on the path to something new, different, adaptive is leadership. 3) A person's personality is less a part of leadership than how he or she interacts with the thoughts, feelings, belief systems, emotions, needs, and wants of other people.[2,5,19]

Another interesting thing about the course is that it gets students to understand how they interact with people in real time, and how those interactions differ based on whether they hold formal authority or not.[20] Students start to recognize that leadership is not equated with authority necessarily, and that the process of leadership is fluid, and something that people do together, whether it is gently driven by an individual or by a group of people.

All those concepts have been applied to a course in arts management.[11] In this course, students learn how to recognize what issues are important, what issues are getting in the way of doing real, adaptive work, and what issues are just noise; they learn how to know what their role is in the leadership process, and to identify the roles of others; and they learn how to resolve the hidden issues so the real leadership work can be done.

This last one is done by learning how to lower defense mechanisms of oneself as well as others and it happens through immediate peer feedback. That feedback is essential to learning.[21] It occurs in small groups of four or five people, where everyone takes a turn each week, over the course of eight weeks, telling a story about their own failed leadership. One person is assigned to be the formal moderator of the discussion, and another is the presenter. Everyone in the group then critiques the failed leadership and discusses options. After each meeting, the group members are asked to fill out a questionnaire about that day's experience. The questionnaires change each week, starting by asking the students to simply observe what is going on, and eventually getting them to examine the core behaviors and responses of individuals. The teacher of the course takes the group members' individual responses and provides individual feedback that encourages the participant to dig deeper into their observations, go with gut reactions, and anticipate how personal adaptation might change the work of the group. Ultimately, each participant is encouraged to attempt to steer the work of the group in one direction or another, and participants learn what each is doing, why, and where that work will lead the group. Strangely, the work is iterative, and though all participants are working in parallel, they are learning how to layer each other's work, and though it may seem unstructured and frenetic, it is actually heading toward adaptation.[22]

Identifying the Real Problem

More often than not, the real problem is buried under the hidden agenda issues of people who work with or around the problem. Finding solutions works best once we can clear away all those hidden issues. Even then, we have to be sensitive to all those issues, to the problem, and to other potential problems; we have to be able to come up with lots of ideas that might resolve the problem; and we have to be resilient enough to not just stick to the first potential solution we find. We have to be able to handle the complexities of personalities and puzzles, we have to be able to evaluate what we are faced with, and we have to be able to change our paradigm. That is an awful lot, and you will notice that it has to do with personal characteristics rather than technical skills.

The very first part of the process is problem finding, where one of two things (or maybe both) occurs. Either time is spent manipulating, exploring, and evaluating the pieces of the problem, or questions are asked about the pieces of the problem as a means of exploration and education about the problem.[23] Because a problem requiring a creative solution is often not clearly defined, returning to the problem-finding phase and doing one or both of these two tasks may occur in a dynamic fashion with other phases of the creative process. It behooves a good leader not only to allow a return to problem finding, but to encourage it.

Everett Galveston had, with the staff at Nirvana Rep, decided that they should consider producing a musical. They considered a great deal of possibilities, discussing the merits of over fifty different musicals, asking questions about each, and exploring both what they represented and what they could mean to a modern audience. For each musical they would ask some fundamental questions about what its clear themes were, and then ask questions about what they felt were potential hidden or buried themes in the musical. This part of their problem finding was clearly the question-asking phase. Then they would discuss potential ways that they could reinterpret each musical, utilizing the existing themes, but placing the story in a more modern context. In this part of the discussion they would examine how the set, the lights, the sound, the costumes, and the casting might all be different. This is where they would evaluate, manipulate, and explore pieces of the problem.

In the case of Nirvana Rep, after discussing several musicals, the staff began to narrow them down to just a handful, and then one kept surfacing as the leading contender: *Jesus Christ Superstar*. The musical is a juxtaposition of the biblical story of Jesus Christ, a sacred, historical account, blended with modern rock music, ballad narration, and the challenges of human nature. Its main theme is that of the nature of star power on a worldwide scale and the fears and needs of those who come in contact with the star, and with the star, himself. Jesus preaches love and acceptance, and strives for it, but is demonstrated as very human and flawed. All of this is mired in the cloak of religion that is seen as both highly organized and commercial as well as grassroots and faith-based, depending on those who preach. The frame of the story is the politics of the time of Jesus. The musical was controversial when it was first produced, not only because this mixture was both enlightening and disrespectful, but because in the Broadway production a black man was cast in the role of Judas Iscariot, the betrayer. Ultimately, it was Nirvana Repertory's exploration of how they could do some sort of non-traditional casting that became the catalyst for reinterpreting *Jesus Christ Superstar.*

From the idea that a woman could be cast in the role of Judas came a new way of thinking about this musical. While the character names would remain the same, and no changes would be made to the dialogue or songs, the story would be that of famed PTL Club founder James Bakker. With the Jesus character representing Bakker, the hordes who followed Jesus became the masses following Bakker. Mary Magdalene would represent Tammy Faye Bakker, and the person who ultimately betrayed Jesus would represent Jessica Hahn, the woman who ultimately betrayed Bakker, though Hahn's betrayal was associated with more than a kiss. In Nirvana Rep's production, the kiss was a metaphor for sexual liaisons.

In the musical, the religious establishment tries to quietly get Jesus, just as the religious establishment tried to knock Bakker off his pedestal, but ultimately, the government, in Pontius Pilate, condemns Jesus. Bakker's fall was also ultimately at the hands of the government in terms of an accounting scandal. For Nirvana Rep's production there would be video camer-

as and reporters following "Jesus," there would be a recording studio from which the PTL Club would tape, and make-up would be essential for "Mary," as Tammy Faye had trademark make-up. The costumes would have to reflect the mid-80s, including Jim Bakker's light blue leisure suits.

The process to develop this creative idea included finding the problem and then determining who the collaborative players would be. This occurred because the people sitting in the room all had predetermined expertise. One was largely focused on sets, one on costumes, etc. Those players had been "cast" by Everett Galveston precisely because they brought different experiences. In the case of this discussion (which actually happened over several meetings that were weeks apart), at one point a heated argument occurred between the director of marketing and the costume designer. The debate centered around how certain types of costumes would not work well to promote a production in photographs. During the debate, Galveston pointed out that this seemed to have been an issue before. With little prodding, what surfaced was a resentment by the director of marketing because the costume designer had, two productions earlier, changed the costumes for a photo shoot without warning. The costume designer apologized for having done so, the hidden issue was resolved, and the debate ceased. The creative process was allowed to move forward, and it was done by everyone in the discussion. Though Galveston had the formal authority, he did not necessarily lead. When the office manager suggested *Jesus Christ Superstar*, it was the office manager who urged ideas for reinterpretation and led the creative process.

How Is Creativity Different?

If leading a creative mind or groups of creative minds is different from leading analytical, linear thinkers, the basis for the work being done must be different. In fact, the creative process is different from the noncreative process in a number of significant ways. In the creative process, there is a major emphasis on defining the problem, because it is not clear from the beginning. There is nothing routine about the solution finding, nor is there anything routine about the problem finding. Technical solutions cannot fit the problem once the problem is found in the creative process. Also, in the creative process, people try multiple ideas that are new, untested, and untried. They think both in ways that are unique from how things have been considered, as well as in ways things have been considered, and then they combine the two schools of thought. In the noncreative process, people use solutions that have been used before, or they have procedures to follow to resolve problems. In the creative process, ideas flow from problem finding, to issue exploration, to layering, and then back through those pieces several times until the solution takes shape. In the noncreative process, ideas follow in a linear fashion from problem to solution to application. In the creative process, existing ideas from specific areas, such as sets or costumes, are modified, or are combined to create new solutions.[24] The idea of incorpor-

ating cameras and a sound stage was the creation of something new for Nirvana. In the noncreative process, existing areas are utilized, rather than new ones being added.

The big challenge in the creative process, however, is the existence of hidden issues, political agendas, and the like. In the case of Everett Galveston, the issue seems relatively small and simple to relieve. More often, however, people have myriad issues that are deeply seated and serve to effectively block the creative process. Until they can be identified, addressed, and thus, dispatched, they make creativity, and leading the creative mind, impossible. The challenge for an effective leader of the creative mind is to develop an ability to spot those hidden issues, to draw them to the surface, and then to keep the pressure on the creative individuals enough to cause the work to get done (or to bring the next hidden issue to the surface). In adaptive leadership, people are challenged by their own doubts and fears. The effective leader helps them deal with that by doling out that which creates fear only at a pace that people can handle.[2]

1. Byrne, U., *Work-life balance: Why are we talking about it at all?* Business Information Review, 2005. **22**(1): p. 53-59.

2. Heifetz, R.A., *Leadership Without Easy Answers*. 1994, Cambridge, Mass.: Belknap Press of Harvard University Press.

3. Guilford, J.P., *Creativity*. American Psychologist, 1950. **5**: p. 444-454.

4. Wallas, G., *The Art of Thought*. 1926, London: J. Cape.

5. Heifetz, R.A., A. Grashow, and M. Linsky, *The Practice of Adaptive Leadership: Tools and Tactics for Changing Your Organization and the World*. 2009, Boston, Mass.: Harvard Business Press.

6. Drucker, P.F., *Managing in the Next Society*. 1st ed. 2002, New York: St. Martin's Press.

7. Goodman, R.A., *Some management issues in temporary systems: A study of professional development and manpower-the theater case*. Administrative Science Quarterly, 1976. **21**(3): p. 494.

8. Mintzberg, H., *Covert leadership: Notes on managing professionals*. Harvard Business Review, 1998. **76**: p. 140.

9. Mumford, M.D., *Managing creative people: Strategies and tactics for innovation*. Human Resource Management Review, 2000. **10**(3): p. 313.

10. Mumford, M.D., *Leading creative people: Orchestrating expertise and relationships*. The Leadership Quarterly, 2002. **13**(6): p. 705.

11. Rhine, A. and S.C. Meyer, *Teaching an artistic staff the skills of leadership: A case study in practical application of leadership priciples in the arts*. The International Journal of the Arts in Society, 2008. **3**(1): p. 141-150.

12. Khaleelee, O., *Personality, life experience and leadership capability*. Leadership & Organization Development Journal, 1996. **17**(6): p. 5-11.

13. Bryman, A., *Qualitative research and the study of leadership*. Human Relations, 1988. **41**(1): p. 13-29.

14. Kirby, P., *Extraordinary leaders in education: Understanding transformational leadership*. The Journal of Educational Research, 1992. **85**(5): p. 303-311.

15. Bryman, A., *The importance of context: Quqalitative research and the study of leadership*. The Leadership Quarterly, 1996. **7**(3): p. 353.

16. Rhine, A., *A great confusion in theater management*. The Journal of Arts Management, Law, and Society, 2006. **36**(1): p. 33-47.

17. Dunham, L., *There is business like show business: Leadership lessons from the theater*. Organizational Dynamics, 2000. **29**(2): p. 108.

18. Parks, S.D., *Leadership Can Be Taught: A Bold Approach for a Complex World*. 2005, Boston, Mass.: Harvard Business School Press.

19. Heifetz, R.A. and M. Linsky, *Leadership on the Line: Staying Alive Through the Dangers of Leading*. 2002, Boston, Mass.: Harvard Business School Press.

20. Heifetz, R.A., *Teaching and assessing leadership courses at the John F. Kennedy School of Government*. Journal of Policy Analysis and Management, 1989. **8**(3): p. 536.

21. Tsui, A., *Do secondary L2 writers benefit from peer comments?* Journal of Second Language Writing, 2000. **9**(2): p. 147.

22. Austin, R.D. and L. Devin, *Artful Making: What Managers Need to Know About How Artists Work*. Financial Times Prentice Hall. 2003, Upper Saddle River, NJ: Financial Times/Prentice Hall.

23. Rostan, S.M., *Problem finding, problem solving, and cognitive controls: An empirical investigation of critically acclaimed productivity*. Creativity Research Journal, 1994. **7**(2): p. 97 - 110..

24. Mumford, M.D., et al., *Process analytic models of creative capacities*. Creativity Research Journal, 1991. **4**(2): p. 91 - 122.

Chapter 7
The Four Pillars of the Framework

"I have been impressed with the urgency of doing. Knowing is not enough; we must apply. Being willing is not enough; we must do."

– Leonardo da Vinci

"When a great team loses through complacency, it will constantly search for new and more intricate explanations to explain away defeat."

– Pat Riley

Carrots and Sticks

There are so many theories about how leadership does and does not work, and why, that it is almost mind-boggling. The reason there are so many airport books is that there are so many theoretical frameworks on which they can be built. The basis for where it all started was an examination of transactional versus transformational leadership.[1] This is the foundation of leadership. The distinction is really the difference, as we now recognize it, between management and leadership. Transactional is about carrots and sticks. We offer rewards for good behavior: a bonus, an hour off early, a "thank you," or something else that makes the employee feel good, valued, and important. We mete out punishment for behaviors we want to curtail: a demotion, a firing, a write-up, a stern "talking to." Sometimes these things

are done more subtly. Off-handed comments often serve as a stick, as when John Precinski once told an employee, "Perhaps you aren't the right person for the job." The comment was simply an observation on Precinski's part, not an evaluation. There was never any telling if anyone was the right person for the job they were doing. Precinski was always looking to find out if someone could improve, or be replaced to cause improvements. His comment about someone "perhaps" not being right for the job was, in Precinski's mind, nothing but an observation. In effect, however, by making that observation, he poked the employee with a very big stick. The comment meant, to the employee, that Precinski did not understand what the employee did, did not value the employee, and would be happy to replace the employee. The employee started a job search that day.

Transformational leadership is something different. Transformational leadership, as the name implies, is about causing change. There is, on the subject of transformational leadership, a great deal of debate about what sort of change is actually transformational. Does a new CEO who causes revenues to increase drastically earn the moniker "transformational" because he has transformed the revenue stream? What if he caused the revenue to get worse, not better? The revenue stream has still been transformed. What about a leader who makes the workplace a much more enjoyable place to be? Is that transformational? Or the woman who streamlines operations, lays off 300 people, reconfigures processes, and gets the company to run lean, mean, and with great efficiency. Is that transformational? In a sense, they are all transformational, because things at each company have been greatly transformed from one thing into another. However, the real question is whether values have changed. Have the people involved been able to adapt? Has there been an accepted experience of going from one set of norms to another?

In the world of a theater rehearsal, the staff (the cast) starts with very few sets of values around their work. The business (the play) has not been together as a going concern long enough to develop behavioral patterns of accepted styles, values, and norms. There are always certain rules that everyone accepts. Absence is unacceptable. Tardiness cannot occur. The rehearsal is a safe place to experiment. This last one is essential in the creative process. In the rehearsal it is cherished. In order to transform from people reading scripts to the world of the play, there must be a great deal of experimentation. So the director embraces new ways of trying things.

Yes and No Men

Everett Galveston had a reputation as being a "yes" man. When he was directing a play, he would routinely holler out, "Yeah, yeah," in the middle of rehearsals, sometimes screaming it to show his pleasure with what the actors were doing. He encouraged everything anyone tried. Galveston was certainly using the carrot of transactional management to accomplish transformational leadership. His carrot, in fact, was in a way the stick as well.

Actors who did not receive a "yeah, yeah" felt they had fallen short on their work, and would step up their efforts of experimentation at the next rehearsal, just so they might hear the coveted "yeah, yeah."

At the end of each rehearsal, Galveston would sit the cast down and reflect on the day's work, reiterating those things that he believed worked exceptionally well. He would encourage cast members to continue down the path of experimentation they had started. He didn't highlight everything he had given a "yeah, yeah" to. In fact, many of those moments didn't make it to the final analysis of the day. But what Galveston was doing was encouraging experimentation. He was encouraging creative thinking. And he used his end of day briefings with the cast to sort through all of the experimentation and focus in on those ideas that seemed most promising. Galveston was leading his creative minds toward a successful new product.

Arthur Fine had taken over Shangri-La Automotive with a plan of his own. He had a new vision for the company based around his own creativity, and he began, almost immediately, to focus on this new vision. The staff, at first, embraced the fact that their new CEO was serious about trying to do things differently. The company had been doing the same thing the same way for quite a while. The staff believed that their new CEO was right in trying to chart a new course.

One particularly bright, newer staff member approached Arthur Fine a couple of weeks after Arthur's new initiatives began being implemented, and he said with all the enthusiasm he could muster, "Mister Fine, I wonder if my team could study the possibility of fabric coverings for dashboard pieces."

Arthur Fine smiled as he contemplated the idea. The staff member thought, during those moments, that simply for asking, he would certainly be given a chance to think up potential new ideas. This was why he became a design engineer. He loved the creativity his job could afford. He reveled in coming up with new ideas. He was energized when he could spend a few minutes...

"No."

"But I just thought that if we spent just a little time focusing on..."

"Stick to what you have been working on," said Fine. "We don't need too much change happening all at once."

"I understand. Do you think we might consider it in the future?"

"Hmmm," mused Fine. "To be perfectly honest, no. Stick to what you have been doing."

This was not the only time Arthur Fine said no. When one engineer asked if Fine would like him to do some fine-tuning to a concept Fine had put forth, the CEO responded, "No." There was no depth of explanation. There was no explanation at all. There was, "No."

The message took very little time and very little effort to reach across Shangri-La Automotive very quickly: Do as you are told, and do not attempt to be creative. The culture changed very quickly. The staff was unhappy

within weeks. The situation became unbearable in short order. This was not a creative environment, but an environment full of frustrated creative people.

In police work, one of the greatest punishments a field officer can be made to pay is to be given a "desk job." One of the greatest benefits to those who aspire to this great profession is that they are able to be out in the community, interacting with people, providing both a sense of safety and a response to need. Those men and women thrive on seeing the faces of those who are saved or feel safer because of the work they are doing. They feel a great sense of accomplishment when they are able to stop something bad from happening, or from happening again. When the people who live for this intrinsic reward are required to sit at a desk, indoors, and process paperwork, they are not only demoralized and frustrated, they are psychologically hurt.[2]

What is it that invigorates your creative staff? What gets their creative juices going and really makes them feel valued? At 3M, creative engineers were once required to "steal" time from the company to work on their own creative projects during work hours. It encouraged creativity without putting any corporate pressure on. If the creative project they worked on amounted to nothing, that was fine. The time was supposed to be stolen. Those people were required to not focus on work projects for several hours each week.

Google is known for people playing basketball in the hallways. Apple Computers had a similar reputation. Likewise for Facebook. Creative people like to play. And simply playing allows the mind to escape from its routine process of linear, analytical thinking. The subconscious goes to work on things that excite it, while the conscious focuses only on playing.[3]

The Four Pillars

In the theater rehearsal there are four pillars that drive the creative process. These are really the four goals of a good director who is trying to encourage creativity and to generate a new project through consensus. If you think about it, the job of a theater director is really very difficult. This person must, in a limited amount of time, get a staff of creative people to create a new product that will be good, and they must do it to the degree that every staff member is completely satisfied with the product. It seems like an impossible task if you attempt to translate it into business terms, but the four pillars are the pieces that hold the process together. The four pillars can be just as easily converted to any creative work group.

Keep the Pressure On

Consider how a pressure cooker works. The food is placed inside, and the heat is kept at just the right temperature to cook it quickly, under pressure. If the heat gets too high, the pressure cooker will explode. If the heat is not

high enough, there is no pressure, and nothing cooks at all.[4] The real trick is in the regulator that sits on the top of the pressure cooker and lets just enough steam out to allow the pressure to stay on, but not become too unbearable.[5] In the theater, the director is the one both keeping the heat on, and letting the pressure off just enough to keep the whole thing from exploding. When the pressure gets to be too much, creative people stop being creative. They withdraw. In the theater we see actors who experiment in a very deep and intense way, and their emotions become so raw in the rehearsals that they are personally affected by those feelings. A good director will note the excellent work but allow the actor to back away from the intensity. Sometimes the director will let the actor not experiment for a day or two, just to regain footing.

What the director always does is keep the opening night date on the edge of everyone's mind. That certain date creates a sense of urgency about the work that cannot be ignored. This is a pressure that encourages the cast to experiment. When the director feels the creativity is lacking, he or she will remind the cast of the pending opening night, and suggest that they are falling behind. This increases the sense of urgency, and hence the pressure. In order to achieve a creative product with consensus, there must be a sense of urgency.[6]

Business leaders sometimes miss this crucial piece. They come into their project without a sense of how important it is. Sometimes this is because they have not considered all the relevant data. What happens if the play is not ready on opening night? Will tickets be refunded? Will audiences see an incomplete production? What happens to the company if a new product is not launched by November? December? January? Where are the numbers now? Where will they be? Does everyone understand the situation? Does everyone see the urgency? This is not to suggest that a good leader creates a panic. A panic is the equivalent to overheating the pressure cooker. No. A good leader makes certain that the level of urgency is understood. This is done with facts, and by sharing them.[7]

There is another thing that sometimes impedes urgency. When cast members are fixated on getting their character just perfect, and they are spinning with the amount of work they are facing, they appear to be very busy, and hence must be driven by a sense of urgency. But when those cast members are mired in the minutiae, the little things of less importance, they are simply busy and not responding to urgency. Business leaders sometimes see a very busy staff working hard, almost to exhaustion, and they mistake that for urgency. Sometimes they lower the pressure because they believe this fast pace may be too much for the staff. A staff that is responding to real urgency is busy, working intensely to find solutions and solve problems, but that staff sets aside the smaller tasks. They are delegated to others or put on a back burner. Real urgency drives real work.[7]

One thing directors like to do is expose their casts to the real world equivalent of what their characters experience. Directing *One Flew over the Cuckoo's Nest*, Brian Artsman took the cast to a psychiatric hospital and had the cast interview the residents and staff. It was an opportunity to know

how the world of the play fit into the real world, but it also left the cast feeling they had much to do if they intended to create a product that would be successful. The trip into the real world created a sense of urgency. Business leaders can send staff into the world to learn, to gather information, to develop perspective. All of this contributes to a sense of urgency.[6]

On the same production, Brian Artsman also brought a psychiatrist in to discuss the characters of the play, and why, from a clinical perspective, they behave as they do. Artsman not only wanted the cast to understand why the characters were the way they were, he wanted the cast to know why they feel the way they do about their characters. Bringing in outside consultants to enlighten a staff on a topic, not just for logical information, but to inform hearts as well, adds to the sense of urgency.[7]

During the preview performance of *One Flew over the Cuckoo's Nest*, Brian Artsman did not watch the play on stage. He sat in the theater, listening to the cast, and he made copious notes on his tablet, but he spent the entire performance watching the audience. He was paying attention to how they were responding. He was using the information they provided to feed the sense of urgency back to the cast. He would keep that sense of urgency going even after the play had opened, so that the product, the play, remained fresh in the public's eye. Artsman also, once a play opened, checked in with the box office staff and the ushers every day to see what they were hearing from audience members about the play. Business leaders can get on the floor and hear what the front-line people are saying. Reading reports doesn't create a sense of urgency; people do.[7]

Nirvana Rep had a production of *Tartuffe* running while they prepared their next production, *Death of a Salesman*. The latter was moving along quite well in rehearsal while the former was selling quite poorly at the box office. Artsman asked his front-of-line staff and discovered that the problems had to do with the particular translation of the *Tartuffe* script, and not the production itself. But there was simply no way to do a different translation. That would require a whole new rehearsal process. Advance tickets for *Salesman*, however, were selling briskly. In an effort to solve his box office crisis with *Tartuffe*, as well as to create a greater sense of urgency around *Salesman*, Artsman decided *Tartuffe* would close a week early, and *Salesman* would open a week early. The crisis became a means for creating greater urgency. Businesspeople are faced with crises all the time. Turn them into tools for urgency.[7]

Brian Artsman was not just about finding urgency in the plays he directed. Nirvana Repertory operated under a constant sense of urgency. Artsman frequently reminded the staff that the next production had to be better than the last. He believed that if a company was to grow, it always had to be doing better, becoming stronger, and improving. He spoke of this sense of corporate urgency on a regular basis, and he instilled it in those he worked with. If someone grew tired, or complacent, or simply tried to be a drag, Artsman encouraged their participation in subtle and kind ways. It was part

of his leadership to ensure that everyone knew what they were doing was not only important, it was urgent.

Encouragement

Brian Artsman was known by his staff as a man who made them feel better about themselves. It was because he was a perennially happy man. He had days when he was happy and days when he was not happy. But he never had days when he was sad, or mad, or angry. More importantly, toward everyone he came into contact with, Brian Artsman behaved positively. People feel better (or worse) based on how others behave toward them.[8] John Precinski was not a people person. But worse than that, he wouldn't recognize people in the hallway. He did not know the names of everyone he worked with. He did not like to smile at others. So the people who worked with him often felt worse about themselves based on how Precinski behaved.

Brian Artsman liked to encourage people to think of new ideas and to try out new things. This level of encouragement came from a place of optimism. Artsman believed that good things would come from experimentation. This is not to suggest that one must believe that every idea is a gem. It is to suggest, however, that optimism will define a leader over pessimism any time.

People are not affected by events, but by their own beliefs. When John Precinski told a staff member that he may not be the right person for the job, the staff member was not affected by the event of the comment, he was affected by his intervening belief of what that comment meant. We all respond to our beliefs, rather than to actual events.[9] A good leader works to make sure, as Artsman did, that our beliefs, if they are pessimistic, are shifted to the positive. Fortunately, shifting our beliefs about events is fairly easily to do if you are aware of how your thoughts, emotions, actions, and comments can affect other people.

Why is that important? Well, optimists do better at work, they do better at learning, they are healthier, and they may even live longer.[10] Encouraging optimism has a clear set of benefits to the great leader. Optimists are more resilient because they do not personalize bad things. Optimists find that events are not related to them as people, but are simply things that occur.[11] This is a key in the rehearsal process. While directors like actors to know what the emotions of the character really feel like, at the end of the rehearsal, directors work to make certain the actor does not connect him or herself to the feelings of the character. A great director helps the actor disengage from the character and not to personalize the work.

Brian Artsman tells a story of a young actress who was having great difficulty separating herself from the terrible despair her character was feeling. One afternoon, at the end of the rehearsal, Artsman told her to go to the dressing room, turn on a lukewarm shower, and let the water rinse away the character. She did, and for her this was the solution she needed. The next day, however, she had difficulty getting back into her work. Early in the re-

hearsal, Artsman sent her to the lukewarm shower and told her to let the feelings of the character wash over her. This also worked, and every day, before and after the rehearsal, and then before and after the performances, she took showers. Artsman had to encourage her to both be the character and not be the character. He developed a trick to encourage her resilience.

Arthur Fine had his own vision. But more than that, he tried to keep the staff at bay. He discouraged them. He said no. Arthur Fine was threatened by the talents of his staff. They were very talented, and he felt a need to be the star. A great leader, who can lead by encouragement, understands that encouragement must occur at all levels of the organization, including within oneself. A great leader surrounds himself with great people and encourages them to become even better. Success for a great leader comes when the staff excels and advances. This is part of the work of a great leader. If Arthur Fine needed to feel like a star, he should have kept reminding himself that he would be a star if his staff developed great, new products. Instead, he discouraged them to stroke his own ego. Self-encouragement will help a strong leader encourage others, as well.

Containing Anxiety

When a matter of importance to us is out of our control, we have a tendency to become anxious. Those who handle this type of anxiety less well are often referred to as "controlling," not because they have a desire to be the responsible party, but because they ease their own anxiety by keeping a situation in control. Control is not a bad thing. In fact, having control is the opposite of letting things get "out of control," which, in business, can be very bad.

Any representation of change to us can induce anxiety. The prospect of change, of a need to adapt to a different set of circumstances, threatens the ego. That threat, then, causes anxiety. Change, and what it leads to, is unknown, and the unknown is threatening.[12]

In our personal lives, we do our best to control every aspect that is important to us: relationships, finances, schedules, and the like. When any aspect of our personal life breaks down, we become anxious and very emotional. We want resolution; even if that comes in the form of change, so the anxiety can be dispelled. While it is not a leader's responsibility to ease anxiety in personal lives, knowing that such anxiety exists can help an effective leader support people with creative minds.

The most effective leaders in theater are those who are recognized for their concern about the personal lives of those they lead.[13] These leaders spend just brief moments asking about the personal lives of those they work with, and the simple act of asking both connects them to people and makes them appear more trustworthy. When anxiety-inducing personal issues occur, these leaders are able to ease the anxiety with well-placed words of support, or words that are remembered as a simple act of kindness - that are appreciated very much by the person who needs to hear these words.

In the professional world, a leader has a responsibility to contain anxiety. The idea of containing anxiety is different from easing it. Because anxiety is generated through a fear of change, that anxiety will actually drive the creative process.[5] It is what causes people to work toward a creative solution that will then displace the anxiety. For the leader of the creative mind, it is important to gauge the levels of anxiety, and to relieve it when necessary. The anxiety is the steam in the pressure cooker.

Brian Artsman tells the story of a Hamlet and a Gertrude who had very distinct ideas about the nature of the relationship between the Prince of Denmark and his mother. Each day at rehearsal, Gertrude would press her ideas, and refuse to try playing the role more the way Hamlet believed they should interact. As Hamlet objected, Gertrude became more resolute. She believed that the two had an incestuous affair. Hamlet could not accept that idea, and would not respond. The rehearsals were becoming less and less productive. Finally, during one rehearsal, the two stopped rehearsing at all and began yelling at each other about each other's talent, or lack thereof. The attacks became personal and loud. In the middle of it, Artsman cracked wise by saying, "Hamlet's father would roll over in his grave if he had to see his only son and his wife fighting about sex. It makes one wonder if he was getting any before he died." Everyone laughed. At the end of the rehearsal Artsman used the argument as a basis for how they should try to develop the relationship of their characters at the next rehearsal. Rather than letting that moment of too much pressure be wasted, Artsman used it to build upon.

In the above story, the tension in the creative process had gotten so high that the debate about how to develop the product became personal. There may have been other hidden issues between the two actors, but at the moment when the anxiety had to be contained, Artsman told a joke. Joke-telling is a very efficient way to release some steam.[5] Of course, there are those who like to tell jokes too often as a means for derailing any process of change whatsoever. In this case, no anxiety is ever allowed to build to a productive level, because the tension is constantly relieved by a jokester. But in any creative process, when the tension runs very high, great work can get done, as long as the pressure is not too great. If it is, someone must make an effort to contain the anxiety.

Lowering Defenses

One thing that creative people do is bring their egos with them into the room. This means that they have a heightened awareness of themselves all the time. In the story of Hamlet and Gertrude arguing, the two actors had conflicting styles, and neither was willing to compromise who they felt they were for the sake of the play. Sometimes, when creative people, egos at their sides, get together, they all approach an interaction with great caution and

even greater walls. They do not wish to have their creative ideas compromised, yet compromise is at the heart of group problem-solving. In order to have a productive process, defense mechanisms have to be lowered.

The trick for a leader of creative people is knowing them individually. A good theater director spends a great deal of time trying to understand each character uniquely. Actors spend hours and hours, months before the first rehearsal, getting to know the characters intimately. Then, when the play is cast, the director does the same with the actors. The idea is to learn enough about their unique needs and wants, as they relate to the work at hand, including the characters, that the actors trust the director. Trust, of course, is what is required if one is going to lower their defenses.[14]

In business, it is just as wise to get to know individual players. Reports and analytics and human resource departments may be great for providing the broad picture, but if you are going to lead the creative minds, you have to know how they think. And they have to trust that you do know. Creative ideas come from people, not reports, and if you understand what motivates people, and what they aspire toward, you will be able to encourage them.[10]

Theater directors work with their creative people directly. They do create the structural framework of a vision for the play, but the cast and design staff then fill out that vision completely. If the structure has to change in the process, the director considers all the players to be collaborative partners in the play's process. They interact together, and the cast and designers have the authority to shape the vision.[10] Successful business leaders need to work directly with their creative people, interacting with them as collaborators and allowing them to have the authority to shape the company. This level of interaction is what defines the creative process.

During rehearsals, what may have been perfect one day could be discarded the next, not because it is no longer perfect, but because there is something even more relevant or better to do. This process of change and adaptation is ongoing. It happens all the way up to opening night, and beyond. In order to keep a play fresh, relevant, growing, and going forward, every day there is some form, however slight, of adaptation. Actors have been empowered to have that level of control.[10] It is the notion that the organization is constantly evolving, not just producing profits, that makes the creative endeavor work at full capacity.

Finally, in the theater, there are people who look at the financials and worry about the bottom line. There are people concerned with profitability and operating costs and capitalization and the like. The director is not one of them. The director does not focus on the end result at all. The director is not even concerned with what the play will be on opening night. A good director knows that in order for a play to be successful, her focus has to be on the process of creation. Keeping the pressure on, encouraging the cast, containing anxiety, and lowering defenses occur during the creation, and it is where these four pillars are essential.

1. Burns, J.M., *Leadership*. 1st ed. 1978, New York: Harper & Row.

2. Kolodinsky, R.W., *Workplace values and outcomes: Exploring personal, organizational, and interactive workplace spirituality*. Journal of Business Ethics, 2008. **81**(2): p. 465-480.

3. Brown, S.L. and C.C. Vaughan, *Play: How it Shapes the Brain, Opens the Imagination, and Invigorates the Soul*. 2009, New York: Avery.

4. Heifetz, R.A., A. Grashow, and M. Linsky, *The Practice of Adaptive Leadership: Tools and Tactics for Changing Your Organization and the World*. 2009, Boston, Mass.: Harvard Business Press.

5. Heifetz, R.A., *Leadership Without Easy Answers*. 1994, Cambridge, Mass.: Belknap Press of Harvard University Press.

6. Kotter, J.P., *A Sense of Urgency*. 2008, Boston, Mass.: Harvard Business Press. xii, 196 p.

7. Kotter, J., *Shared urgency*. Leadership Excellence, 2008. **25**(9): p. 3.

8. Dreikurs, R. and L. Grey, *Logical Consequences: A Handbook of Discipline*. [1st ed.] 1968, New York: Meredith Press.

9. Ellis, A., *Reason and Emotion in Psychotherapy*. 1962, New York: L. Stuart.

10. Seligman, M.E.P., *Learned Optimism: How to Change Your Mind and Your Life*. 1st Vintage Books ed. 2006, New York: Vintage Books.

11. Dinkmeyer, D. and D. Eckstein, *Leadership by Encouragement*. 1996, Danvers, MA: CRC Press.

12. French, R.B., *The teacher as container of anxiety: Psychoanalysis and the role of teacher*. Journal of Management Education, 1997. **21**(4): p. 483-495.

13. Rhine, A.S., *Leadership in the theatre: A study of the views of practitioners on effective and ineffective styles*. The International Journal of the Arts in Society, 2009. **4**(2): p. 387-398.

14. Dunham, L., *There is business like show business: Leadership lessons from the theater*. Organizational Dynamics, 2000. **29**(2): p. 108.

Chapter 8
Creative People

"My routines come out of total unhappiness. My audiences are my group therapy."

– Joan Rivers

We Are All on Board

Joan Rivers is a comedian, so she speaks to her experiences as a comedian. But if one considers that what she does is actually her work, there is a bit more depth to her quote. When she speaks of her routines, she is talking about all the preparation, innovation, experimentation, and creativity that she puts into developing an entire routine. Her description of them coming out of unhappiness really suggests that her work is developed and motivated by personal feeling rather than technical skills. Certainly, this is the creative mind at work, doing what they do with their own emotions, their ego, as the foundation of the work. The interesting thing is that being emotionally invested in one's work is universal. In work groups, those who create together, being emotionally invested in the group as a type of family unit adds to the complexity of emotions that serve as the foundation of work.[1]

Rivers cracks wise about her audience, saying they are the group therapy that helps her through the unhappiness that drives her work. If her emotions drive her work, then her work is done in anticipation of a response from her audience that serves those emotions. In our analogy, her audience is the marketplace, and the response of the market is what serves the emotions that drive her work. It is not unlike other businesses that are fueled by consumer satisfaction. While the corporation may not have emotions that are fed by a positive market reaction, the creative team that develops a product does have emotions that will be fed by a positive market reaction. This is at the heart of why creative people require recognition on an individual level, and why leaders in the arts are more successful when they provide some level of individual connection.[2]

The marketplace is not only where our products and services end up. The marketplace drives what is being created. But more than that, the marketplace is part of the creative process. For the full band of creativity to occur, many layers of stakeholders are involved. Effective leaders always aim to meet or exceed the satisfaction of their stakeholders.

Brian Artsman always used his preview performance to let the audience into the creative process. Before the curtain, he would deliver a speech, explaining that the production was ready to be seen, but the actors were not finished with their work. The purpose of the preview audience, as Artsman told it, was to help the actors learn how to respond to the audience. If there was laughter, actors would have to let it die down before continuing. If there was applause, likewise, the cast would have to wait. If there were sobs coming from the audience, this would affect the actors emotionally as well. All of these things were an important part of communication.

In theater there are really three forms of communication going on. There is, of course, actor to actor communication. The audience comes to see this occurring. There is also actor to audience communication. If the audience was completely silent, the actor would be numbed by it. The energy of a live performance is not generated by the actor, but by the interplay between actor and audience. The third layer of communication is audience to audience. We all have heard that laughter is infectious. We know that if one person yawns, the rest of the room is likely to follow. And when someone begins to applaud, we all instinctively applaud. When others cry, we are saddened. These learned responses, all emotionally based, also feed the energy of live performance. In fact, the audience is not only the reason we provide the play (the product), they are also part of its creation. Each audience is different, so each performance is slightly unique and different.

What Is an Audience?

The word audience, being a singular thing, suggests that, in some sense, the audience functions as a single entity, rather than as lots of individuals.[3] The same can be said for the market, though, in fact, the audience and the market are full of individuals. What the audience does, and what the market

does, is recognize that the supplier of product (the cast or the corporation) has entered into a system where they, both cast and audience, are jointly participating in some form of communication, each with their own authorized part of the process.[4] Some of what we are expected to do is unspoken, such as laugh, cry, applaud, feel, respond, but it is implied in that authorization. This is why Brian Artsman so concerned himself with the audience at a preview. They were not simply guinea pigs, they were representative of the entire universe of audiences that would see the play, and they were part of the creative process. Each person in the audience brings their own perspective, background, and history to the creative interaction, so a sample cannot ever perfectly predict the overall contribution.[5] Though a sample, at least, is essential to be successful in creation.

People from the marketplace have a very important role in the creative process as well. They are not simply the consumers, nor are they only how we determine what products are desired and required. The successful leader of the creative mind knows that he or she must include the marketplace in the creative process.

Casting

It has been noted that casting is 90 percent of directing.[6] The reason this maxim exists is because casting can make or break a production. The people who will be involved in the creative process not only need the technical skills, they must have the right emotional balance and the ability to fit and work together. The cast also has to know, understand, and be able to work with the audience.

Brian Artsman was fond of asking actors who were auditioning what they liked to read, where they liked to dine, and what the last five plays were that they saw. This latter question was asked to determine if these actors were actually part of the theater-going market or not. He assumed that if they were regular theatergoers, they would better know how to interact with an audience, because they regularly interacted as an audience member.

There are three basic principles in hiring, and they apply to casting as well. When you are looking for good people, the trick is to get them, keep them, and grow them.[7] In human resources parlance that is hiring, retention, and development. The people in human resources will usually tell you that the bulk of their time is spent trying to fix employees who are not doing well, are not right for the job, or are not right for the company. Being more astute at hiring, especially creative people, is vitally important. Of course there are all sorts of psychological profiles and tests and checks that can be done to help make a hiring decision. Most of us go with our gut after a few minutes of interviewing a candidate. That, however, doesn't really seem like a best practice. It is no wonder human resource departments have to fix hiring mistakes.

When casting a play, a director makes the first critical decision in the first two minutes of an audition. This is where people are "typed" out. Their physical appearance may not be right for the character. Their voice may not be right. They may project the wrong style or strength, or they simply may not demonstrate strong technical skills, regardless of what their resume says. Most casting decisions are not made in those first two minutes, but they are the decisions to eliminate people from the pool. Those who remain are called back for further investigation. During those callbacks, actors are often asked to act sections of the script of the play for which they are auditioning. This gives the director an opportunity to see them doing the work for which they are being hired. Occasionally they are paired with others whom they might potentially be working with to act scenes from the play. This allows the director to see the interplay between the actors as they perform the characters. During these callbacks, directors usually like to provide some feedback to auditioning actors, guiding and directing them a bit, just to get a sense of how they respond to feedback. Actors who do not respond in a positive fashion, or who cannot apply the feedback, are usually dismissed. Those who ask questions and attempt to expand their performance are often kept.

In the corporate world there are parallels. Certainly those first interviews are a great place to eliminate people, but they are not the best place to do the hiring. Like casting a play, the interview is the first audition. For those who pass, there is a callback. At the callback, the potential employee is shown around and given someone to work with. They are given a chance to see what the work is like, what the work group is like, and what the corporate culture is like. More people leave jobs soon after hiring because they do not have a good sense of what the corporate culture is, and when they arrive, they discover quickly that it does not suit them.[8] People spend a great deal of their lives at work. Being at work in a culture you cannot mesh with is unbearable.

Another good reason to really interact, as working colleagues, with a potential new hire is that when people decide to leave a company, it is usually not because they have decided to leave the company. It is because they have decided to leave the boss.[7] People not only need to know what a company is all about (culture), but they also need to know how they will engage with the company, and this means knowing and having appreciation for the boss. For creative people, having a connection with the person who calls the shots is essential. The cast spends every day working with the director. It is a very hands-on, interactive relationship. It drives the quality of creativity. If you cast good people, then you know what you are getting. And if you are diligent in the process, take the time to find out if they will acclimate to the director and the rest of the cast, and have made certain that they know what they are getting into, then you can be fairly certain you will retain them. But actors want one more thing from a role: they want to grow as an actor. They like to feel appreciated for their work and the contribution they can make to help make the production a success.

People like to get ahead, and in order to do so, they must improve. An actor looks for a director and other actors to challenge him, so that he can improve his skills and grow as an actor. One successful role will lead to another and so forth. Actors hear all the time about the person who got a tiny role, and then a bigger role, and now they are a huge celebrity. No one is actually *found* at Schwab's. Do employees in your company hear about the success stories of people who started at the bottom and rose to the top? Do people do that in your company? If they do, then others can. Providing a clear path for those who wish it goes a long way toward helping employees grow.

Bureaucracy and Organizational Charts

Can you imagine drawing an organizational chart for a play? It would be the flattest organizational chart in history. There is the director on the top and everyone else below it. Plays are nimble. The decisions are made by one person, and everyone has immediate access to them. There is no long delay while several layers of bureaucracy consider a request for interpreting a role one way or another, or to approve the purchase of a walking stick because some actor feels his character has a limp. Perhaps that is also part of the danger of theater, but it is certainly what makes the creative process nimble.

Very few commercial plays are ever successful. The percentage is small. Because ultimately, no one ever really knows if the application of technical skills, as they are combined in creative new ways, will actually do what the cast and crew think it will.[9] The same is true for innovation. Markets are tested and studied. Products are designed to fill niches based on customer demand.[10] But ultimately, no one knows if they will really hit.[11] Even venture capitalists recognize that successful outcomes are usually not prescribed by the data and the numbers in the business plan, but by factors that have to do with human beings and their drive for success.[12]

While those market analyses do provide some hedging against the bet on a new venture, they are far from perfect. Julie Taymor, the original director of *Spider-Man: Turn Off the Dark* on Broadway, refused to use or listen to focus groups, a primary source of market testing for Broadway musicals. Her rationale for not using or listening to them was that she believes the source of creativity comes from the creators and not the market.[13] There may be some wisdom in this position, since the creative work Taymor does is creating art. But when the art is being created in "commercial" theater, principles of commerce seem to be equally as valid as Taymor's freedom of expression to create.

The truly innovative people in this world are almost fanatical about their desire to innovate. Actors have to be. There are so many actors, and so few acting jobs, that the actors unions have ridiculously high unemployment rates. But when it comes to an opportunity to be in a play, actors are so obsessed about making a great play that nothing can stop them. Regardless of the frustrations or challenges, the struggles or the battles, actors persevere.

Innovators in business do the same, because they are fanatical about what they do.[II] They also tend not to worry about how long it will take to achieve success. Every good director will tell you that the best plays always seem to fall behind and have to rally at the last minute.

That rallying, in innovation or in the theater, occurs because several people are banded together to achieve a creative result. When there are more minds working on a creative project, there is a greater chance for success. The bad theater director is the one who wants to dictate how everything should be done, and doesn't allow the cast to develop their own creative ideas. Too many people working on a creative project can cause confusion, but six or seven people tackling a problem, like a scene in a play, for example, can really build on each other's ideas. Those creative people do not have to worry about a committee studying their work, or a board approving it, or a layer of bureaucracy delaying it. They can do their experimenting without interference. The freedom from the corporate structure empowers creative people.

Those creative people are also rewarded for their creativity. In theater, at the end of a great performance, the audience will leap to its feet and cheer. Actors are greeted by fans waiting at the stage door for an autograph. Reviewers write glowing and generous praise for the performance. This recognition is what a cast works for. Their creativity is rewarded by the praise they receive in many ways. That praise will eventually build their career, as well. The same is true of innovators in business. They desire recognition for developing something successful. Money is nice, but the desire for praise and power and independence outweighs it.[II]

Those fanatical innovators, the ones we so carefully screened into our company, often are not there when we go looking for them. Corporations see the creative people as a bit strange, edgy, and even sometimes not team players.[II] The biggest challenge in hiring is knowing that you are looking for someone who needs the praise at the end, and who can work like crazy (sometimes literally) just to get to the praise. Corporations often have a very well-defined system of benefits and rewards for a job well done. That can get in the way of innovation. It would do businesses good to keep that system of rewards flexible. Every innovation is not the same, nor is every innovator. Every award should be just as unique.

If a company cannot have an organizational structure as flat as that of a play, it can consider mixing up the organizational chart. Sony Corporation is known for hiring nontraditional people into managerial positions (such as an opera singer), for promoting young people into management jobs over their elders, and for creating unique awards for innovative achievements.[II] Sony also has technical people, the innovators, spend time during their training working in sales. Sony feels it essential to connect the innovators to the market directly, much like Brian Artsman does when he casts only actors who are regular theatergoers. Companies might also consider hiring technical people, the people doing the creating, into higher ranks of management, keeping the two layers connected. Of course, the most successful companies at innovation and creation have very flat organization charts.

One other thing about bureaucracy. It includes rules. Creative people cannot function if they are bound by rules. They need to be able to move quickly, to learn from each other, to make decisions about which direction to head, to communicate quickly and effectively, and to learn from each experiment. Bureaucratic environments are designed to slow down, impede, and obscure all of that for protective reasons. Creative people need protection from the very policies that are supposed to protect the organization. Also, creative people need information. Brian Artsman introduced his cast to experts in psychological issues. Innovators in business trade ideas with other groups outside of their company, and some businesses even embrace this idea and work to find groups to trade ideas.[14] Creativity can happen in isolation, but it is informed by experience. Sharing ideas can build on those experiences by adding to them the experience of others.

Using Authority

Brian Artsman is fond of starting rehearsals by playing some sort of theater game with the cast. They might all play at being some piece of sporting equipment, or act out an emotion without making a sound, or just do some calisthenics. In this process, Artsman engages as part of the team, not as the director. Each day, someone suggests a game, and as a group they decide which game they will play. There is no formal authority in this process. Artsman holds formal authority, but he transfers it to whoever suggests a game, and allows that authority to change from day to day. The authority that Artsman has, and that he transfers to others, is never forced or forceful. It is simply there for practical reasons. Someone has to keep the ball rolling and relieve the pressure if it gets to be too much. All the players are brought together without forcing authority, as creativity diminishes in direct proportion to the apparent levels of formal and/or stringent authority. And as creativity diminishes, performances become contrived, and effectiveness becomes lost in the hushed silence of those who can't wait to exit the theater.

1. Saavedra, R. and L. Van Dyne, *Social exchange and emotional investment in work groups.* Motivation and Emotion, 1999. **23**(2): p. 105-123.

2. Rhine, A.S., *Leadership in the theatre: A study of the views of practitioners on effective and ineffective styles.* The International Journal of the Arts in Society, 2009. **4**(2): p. 387-398.

3. Goodwin, C., *Audience diversity, participation and interpretation.* Interdisciplinary Journal for the Study of Discourse, 1986. **6**(3): p. 283-316.

4. Goffman, E., *The neglected situation.* American Anthropologist, 1964. **66**(6): p. 133-136.

5. Bohannan, L., *Shakespeare in the bush.* Natural History, 1966. **August/ September**: p. 28-33.

6. Cohen, R., *Theatre.* 9th ed. 2010, New York: McGraw-Hill.

7. Peterson, C.H., *Employee retention: The secrets behind Wal-Mart's successful hiring policies.* Human Resource Management, 2005. **44**(1): p. 85-88.

8. Deal, T.E. and A.A. Kennedy, *Corporate Cultures: The Rites and Rituals of Corporate Life.* 1982, Reading, Mass.: Addison-Wesley Pub. Co.

9. Mandelbaum, K., *Not Since Carrie: Forty Years of Broadway Musical Flops.* 1st ed. 1991, New York: St. Martin's Press.

10. Hippel, E., *Get new products from customers.* Harvard Business Review, 1982. **60**(2): p. 117.

11. Quinn, J.B., *Managing innovation: Controlled chaos.* Harvard Business Review, 1985. **63**(3): p. 73-84.

12. Zacharakis, A.L., *A lack of insight: Do venture capitalists really understand their own decision process?* Journal of Business Venturing, 1998. **13**(1): p. 57.

13. Healy, P., *Superstars Never Guessed the Size of 'Spider-Man' Challenges,* in *The New York Times.* 2011, New York Times Company: New York City.

14. Allen, T.J., *Managing the Flow of Technology: Technology Transfer and the Dissemination of Technological Information Within the R&D Organization.* 1977, Cambridge, Mass.: MIT Press.

Chapter 9
Fitting the Pieces Together

"There can be no knowledge without emotion. We may be aware of a truth. Yet until we have felt its force, it is not ours. To the cognition of the brain must be added the experience of the soul."

– Arnold Bennett

Speaking or Thinking

In a play, the actors perform dialogue. The play unfolds through the information conveyed in that dialogue. The information represents things that have occurred, will occur, or are occurring. The words are actual representations of things that physically appear in the world, or at least that would physically appear in the world of the characters if it were a real world. Words communicate actual things, and we use them to express thoughts about those things.

In the rehearsal process, where the play is being created, actors do something quite different. They are learning about the environment in which the play takes place. The cognition of all their surroundings, of the words they will say and the words they will hear, is part of the development of that creation. They learn where things are on the set, how other actors react and respond, and how they will respond. In some sense, they are using

the environment of the play in the rehearsal period to eliminate the need to think about all its elements when the play is finally finished. Paradoxically, the repetition that allows the creation in the rehearsal, the cognition, to become the recitation in the performance, is exactly what actors try to avoid. When we have learned enough to simply re-use previous thoughts, we cease to be creative.

The repetition is important, though, because it allows the actor, the creative, to acquire a set of skills and knowledge pertinent to the task, the playing of a character. Those skills and knowledge eventually become not a collection of separate skills and memories, but a single collection that we refer to as the character.[1] The character, in turn, is part of a system we refer to as the play, which includes the players, the environment, and the audience. The important part of developing this collection for the actor is that when the actor becomes comfortable with the skills and knowledge of the character, the actor is able to be flexible to respond to changes in the system of the play. If an actor drops a prop that is normally not dropped, or if there is a change in the way another character behaves, the actor is comfortable adjusting.

It is important to understand what is going on in the brain (any brain) when cognition is taking place. Certainly, we all know that there is a firing of neurons, a storage of memories, and interlacing of previous thoughts to build ever increasingly clever new ones. But there is another school of thought about how cognition occurs, and it actually comes from researchers in artificial intelligence.[2] The idea is that the brain (human or otherwise) is embodied, but is part of the complete network of learning that includes outside sources. The physical world is an essential part of the learning process, both for input and for output. The notion that external stimuli serve as input for cognition is relatively easy to understand. We sense something and learn from it. This is opposed to the idea that our neural impulses determine decisions and then cause us to react to something in the physical world. The cognitive process, in essence, is part of the physical world, including the body.[3]

Understanding this idea is important to understanding how the creative mind, especially, works. The actor is a great place to start, because the processes of an actor so clearly demonstrate and take advantage of the idea of embodied cognition—that our learning is not only brain, but brain (feelings and thoughts), body, and environment. All learning comes from the external environment.[1] Where the challenge comes is when we consider abstract thought. How do we learn about feelings or emotions, which are experienced separate from the physical world? The same question can be asked of concepts or constructs like religion or politics. Even artwork, which can be experienced in the physical, has an abstract component to it. The philosophers on embodied cognition suggest that for all of these things, we develop metaphors that help us to understand abstract things.[4]

Take, for instance, the religious concept of God. Because we cannot experience God in the physical world, we develop a metaphor for God and sometimes refer to him as father, because we have experienced fathers and

understand their relevance. The metaphor of father serves our embodied cognition. Vague concepts become clear when we apply a metaphor.[5]

For an actor, or anyone working on a creative project, there is both real-time and off-line work going on. Off-line work is cognition that does not require the current input of the physical world. Planning, for example, or daydreaming, requires no current physical input.[6] But situated cognition, that is, learning that requires interaction with the physical world, occurs in real-time.[7] Real time involves our past, our present, and even our future. And because this is the case, the cognition occurring in real-time must, in effect, deal with time pressure constraints.[3] This is important because it means that when we are learning and developing thoughts based on the external environment, time pressure may cause us to cut corners and find easier solutions.[8] So we have just recognized a paradox in leading the creative mind. We keep some pressure on, especially in terms of time constraints, but by doing so, we diminish the capacity of the creative mind to expend energy on planning and watching, listening and absorbing, and then taking action.[3]

So under time constraints, we may choose to use answers we already have, rather than developing new thoughts or ideas. Another thing we may do is use the physical world for assistance. We may use the physical environment as a source for achieving ideas, such as counting on our fingers or organizing things to get a better physical picture of how something should look,[9] or we may throw out unformed ideas and see what comes back.[3] What seems clear, however, is that when we repeat something over and over, it becomes much easier to work cognitively, without being pressured by time.[10] Actors, then, become a good, working example of how to relieve the time pressures of learning by rehearsing a play repeatedly, both for purposes of finding creative solutions, and making the ability to think on one's feet easier. Adaptation is simplified as the play becomes *learned*. All creative minds, in fact, need to go through a process of idea generation where the idea is iterative. The model is repeated, with slight alteration, so that the model becomes comfortable while the creation is occurring.

Consider any activity that requires practice—playing tennis, for example, or painting a portrait. Someone who picks up a racket for the first time cannot play as well or make simple adjustments to different returns as well as an expert. A portrait may look misshapen when painted by a novice, and color choices and movement of the subject and the like seem insurmountable, but for the expert, these distractions simply require slight adjustments. Creative people require both practice at creating, so that they are able to deal with time constraints, both real and perceived, as well as some degree of pressure to encourage true adaptation.

During a rehearsal at Nirvana Repertory an actor named Thomas had a difficult time. At this particular rehearsal all the staging had been completed. Actors had developed where they would be standing at any given point in the script, when they would be moving, and how and why. This rehearsal was the first opportunity the cast had to repeat the staging that had been developed. Several minutes into the first scene, Thomas grew visibly frustrated. He had crossed the stage while saying a line of dialogue, and

when he reached his destination, he kept turning, looking around, checking his script, and looking around some more. His motions drew everyone's attention, and before the scene progressed much further, the director asked the cast to stop. She then asked Thomas if something was the matter.

"Something's not right," said Thomas.

"What do you mean?" inquired the director.

"Well, I know I'm supposed to cross on that line, and I know this is where I'm supposed to be, I have all that jotted down in my script," he replied with angst in his voice, "but we aren't all in the right places."

"I'm not sure I understand," responded the director.

"This just isn't right. This is not the way it was when we blocked it. Someone is in the wrong place."

The stage manager chimed in.

"Ginny missed a cross on her line. She should be on your left," said the stage manager.

"Oh yeah," said Ginny, "I thought I had missed something."

With this, the director asked them to back up in the dialogue so they could try it again.

About fifteen minutes later, Thomas stopped again after he crossed to the dining room table, a rehearsal piece of furniture with rehearsal props on it.

"I'm sorry," he said, "but something's not right again."

The stage manager turned pages in his script quickly and then said, "Everyone's in the right place, Thomas. This is how we blocked it."

"It's not that. I'm sorry, but something is wrong. Is this the way the table was set?"

The stage manager looked at the table and sighed and said, "I only set three places because one of the plates broke. Normally there would be four."

"Oh," replied Thomas, "sorry for stopping everything. I knew something didn't feel right. I didn't mean to make a fuss over rehearsal props."

Thomas, and his colleagues, presumably, used their physical environment to a great extent in cognition. The way things were placed around them helped them develop a mental image of what the environment should look like as certain lines were delivered and certain reactions occurred. In an early rehearsal, Thomas knew the image in his head was not fitting the current physical world, though he had not yet learned to see the differences. Actors, like many creative people, develop a skill for absorbing their external environment as part of their creative process. Most people have what is known as change blindness. That is, on a second, early, or brief exposure, they cannot see that something has changed.[11] But seeing something repeated resolves change blindness. Creative people develop a skill for minimizing change blindness. Doing so as a leader of the creative mind assists in the leadership process.

Gesturing

Actors use gestures as part of their work. We all use physical prompts and verbal cues as gestures as a part of the communication process. As it turns out, gestures really are not so important to communication. Instead, their greatest function is to help us think better about what we are communicating.[12] They make the sending part of the communication cycle easier. That is an interesting notion, because it implies that the actual, physical gesture is less important than the idea of the gesture, and what they do for us in terms of thinking. We think of a gesture as some physical movement that expresses a thought or a feeling, but it is actually a physical movement that helps us develop and discuss a thought or feeling.

Michael Chekov, a famed director and protégé of Konstantin Stanislavski, developed his own technique for teaching acting, and one of the core principles in it is the idea of the psychological gesture.[13] The idea behind the psychological gesture is that an actor devises some sort of universal gesture that most characteristically represents the character he or she is portraying. For example, a very stern, demanding character might have the psychological gesture of a pounding fist. The actor does not necessarily use this gesture in his or her portrayal, but the gesture is known and influences physicality. The idea of that gesture helps shape what the actor does.

The idea of psychological gesture goes further, as there can be different gestures for different scenes (all based on the original gesture), but what is important is that the psychological gesture serves the same function as the real gesture. It helps develop and communicate thoughts and feelings. The physical motion is unimportant. For the leader of the creative mind, knowing how creative people behave, how they are embodied by some particular idea of physicality that helps them communicate thoughts and feeling, is important. If we understand how people are communicating and why, we can help them improve and expand the development of a creative idea.

One other notion from actor training: Actors understand that characters have the persona of who they really are (the face) and the persona of how they behave around certain people or in certain situations (the mask). People do this too. Learning to perceive what the mask is and what the face is can be very beneficial to the leader of the creative mind.

More Actor Training

One other thing Michael Chekhov taught was the idea of three aspects that make up a person, an actor, or even a whole play. They are ideas, feelings, and will impulses.[14] The former two are easy to indentify, as they are represented by the metaphors of head and heart, logical and emotional. The latter of the three, will impulses, is the one that is most interesting for leaders of the creative mind. The idea of will impulses is rooted in philosophers like Aristotle and Nietzsche, who talked about free will and the power it

possesses. The notion is that there is an unseen force or power that guides movement, and if this force is depleted, the movement stops.[1] Stanislavski talked about the actor's objective, and will impulse is a similar idea. An actor thinks about what action he wishes to take, and he wills that action to occur through this energy or force. Of course, there is no scientific evidence to suggest that a force or unseen energy is driving any motion whatsoever, but it is a metaphor that actors use. There are even actor exercises designed to use and control this energy.

Think about it. Haven't you ever heard someone say the energy in the room was "electric," when, in fact, there was nothing electric in the room, other than in the traditional, scientific sense of the word? It is a standard phrase in the theater—the show has a great deal of energy, or that one performance had more energy than another. The phrase is not in reference to how much exertion was put into the performance. It is in reference to some unseen sense of excitement or participation in the communications between actor and actor, actor and audience, and audience and audience.

The metaphor of energy is a representation of this level of communication that is vibrant and efficient and effective, and it gives participants a deeper sense of connection to those with whom they are communicating. Chekhov may not have articulated it in this fashion, nor did he reference the great philosophers who understood the power of will, or life impulses, but he knew that an actor's goal was to understand that feeling, and to attempt to recreate it as much as possible.

There may be no perfectly effective route for capturing that sense of strong energy, or of recreating it or even controlling it, but for creative people, we know that when they are most effective, when the play is most successful, people walk out of the room saying there was a tremendous energy. Knowing some simple techniques that actors use to understand their own energy may help the leader of the creative mind to better understand how to tap into that energy, or at least to help creative people attempt to do so. Oddly enough, it is not energy at all, but a sense of communication that has to do with how one feels, both physically and emotionally. Without actually dealing with energy at all, one can change how one feels, and doing so is the best way to lead the creative mind.

1. McVittie, F., *Top-down and bottom-up approaches to actor training.* Journal of Visual Art Practice, 2007. **6**(2): p. 155-163.

2. Pfeifer, R., *Sensory-motor coordination: The metaphor and beyond.* Robotics and Autonomous Systems, 1997. **20**(2-4): p. 157-178.

3. Wilson, M., *Six views of embodied cognition.* Psychonomic Bulletin & Review, 2002. **9**(4): p. 625-636.

4. Lakoff, G. and M. Johnson, *Philosophy in the Flesh: The Embodied Mind and its Challenge to Western Thought.* 1999, New York: Basic Books.

5. Lakoff, G. and M. Johnson, *Metaphors We Live By.* 2003, Chicago: University of Chicago Press.

6. Clark, A., *Towards a cognitive robotics.* Adaptive Behavior, 1999. **7**(1): p. 5-16.

7. Brooks, R.A., *New approaches to robotics.* Science, 1991. **253**(5025): p. 1227-1232.

8. Beer, R.D., *Dynamical approaches to cognitive science.* Trends in Cognitive Sciences, 2000. **4**(3): p. 91.

9. Kirsh, D. and P. Maglio, *On distinguishing epistemic from pragmatic action.* Cognitive Science. **18**(4): p. 513-549.

10. Ballard, D.H., *Deictic codes for the embodiment of cognition.* The Behavioral and Brain Sciences, 1997. **20**(04): p. 723.

11. Simons, D.J., *Change blindness.* Trends in Cognitive Sciences, 1997. **1**(7): p. 261.

12. Iverson, J.M., *Why people gesture when they speak.* Nature, 1998. **396**(6708): p. 228-228.

13. Chekhov, M., *To the Actor: On the Technique of Acting.* [1st ed.] 1953, New York,: Harper.

14. Chekhov, M., C. Leonard, and N.V. Gogol, *Michael Chekhov's To the Director and Playwright.* 1st Limelight ed. 1984, New York: Limelight Editions.

Chapter 10
Exercising Your Creative Leadership Muscles

"I play to win, whether during practice or a real game. And I will not let anything get in the way of me and my competitive enthusiasm to win."

– Michael Jordan

"Let it be your constant method to look into the design of people's actions, and see what they would be at, as often as it is practicable; and to make this custom the more significant, practice it first upon yourself."

– Marcus Aurelius

"He who loves practice without theory is like the sailor who boards ship without a rudder and compass and never knows where he may cast."

– Leonardo da Vinci

Practice Makes Perfect

It has often been said that practice makes perfect. We know that to excel, people practice. To become an exceptional and fast typist, a person has to work at it for weeks, months, even years. Concert pianists practice not only difficult, challenging pieces of music, but they practice their scales every

day. It is said that Olympian Michael Phelps practices swimming six hours a day, six days a week. But more than that, after he is done in the pool, he does scores of abdominal exercises with his stretches. That is a lot of practice.

Orchestras practice, dancers practice, and we even refer to the work that doctors and lawyers do as practice, implying that they are always improving. It also suggests that perfection in all of these arts is unattainable. The work, the art, is a process rather than something that can be mastered.

Those who excel at sports spend countless hours practicing. In all of those cases, when the goal is to become the best (perfection is not achieved but the measure of the success of practice is in the comparison against others), the practice is not only consuming in quantity, but in quality as well. Michael Jordan notes in the quote at the beginning of the chapter that he invests just as much energy and enthusiasm into his practice as he does in a game. To him, they are all part of the process, neither deserving less focus than the other.

The previous chapters of this book have all focused on theory. Of course, that word tends to make things feel weighty and difficult when they need not be, so instead, we looked at why things work through the practices of two different companies and their various executives. The DaVinci quote at the beginning of this chapter justifies why the book is organized the way it is. In order to effectively practice leadership of creative people, you have to understand the theory behind leading the creative mind. There is an awful lot going on when it comes to interacting with people, and creative people can sometimes be even harder to understand and work with, much less lead. The theories about how and why creative people tick help inform some very simple exercises you can do to improve your leadership skills.

Reflection and Sensitive Engagement with Others

Marcus Aurelius said we need to "look into the design of people's actions," but added that in order to make this practice "significant, practice first upon yourself." Aurelius may not have been thinking specifically about leading the creative mind or even about leadership in general, but when it comes to understanding why other people do what they do, you must be willing to examine why you do what you do. Knowing why you are the person you are, and why you make the choices you do, changes your practice of trying to understand others. Rather than that being a judgment of why others are the way they are, it becomes a comparative understanding. People do things for similar reasons as you, or for different ones. You understand them, with yourself as a frame of reference. So the exercises for reflection and sensitive engagement should come with this general rule of thumb: *Always reflect on your own choices, and try to understand what has influenced them.* There have been many times when I made a choice because I wanted to give a little extra benefit to one person over another, almost as an unseen reward. As I reflected back, I began to realize that I preferred one person over another not because the person handled work more effectively or efficiently, but

just because I liked the person more. The appropriate response would be to provide something "extra" by sharing personal time, and not by using work influences to give preferential treatment. Understanding this has caused me to change how I interact with people. I try to always reflect on choices.

1. Learn your own face from your own masks.

 Actors use masks to hide their real expressions, to limit the use of their faces, and to emphasize physicality. Each mask represents a different character, though the actor does not change. Actors also learn to consider that the real person they are (face) is different from the one they are playing (mask) and that each character has a real persona (face) and different masks depending on the situation. You probably are different at home with a spouse or partner (face) than you are with your boss (mask) or your friends (another mask) or your parents or family (yet another mask). Would you know how to act if all those people gathered in the same room at the same time? Every time you leave an encounter with someone else, take sixty seconds to think about what makes the mask you were wearing with that person different from the other masks you wear, and from your real self. Were you more tense? Did you speak differently? Did you speak less? Were you happier? Were you bored? Sixty seconds goes by fast. Think hard about why you were different in each encounter. Write it down if you can.

2. Learn the masks others wear.

 Once you feel comfortable that you are beginning to understand and easily interpret what masks you are wearing and how they differ, start trying to make the same interpretations of others. Add sixty more seconds to the end of each encounter (the first sixty seconds may now only take thirty or less) and think about what the person or people you were engaged with did that seemed unusual. This is especially effective when you engage with the same people a great deal, and with many people simultaneously. At first, you may think that you cannot see anything unusual or different about others. Force yourself to "guess" at what might be going on. Human beings survived extinction itself because we developed a very strong intuition. Modern life suggests we should trust data (what people tell us) and not intuition (what we think about them), but your intuition is as good now as it was for your ancestors on the plains. Use it and trust it.

3. Work on change blindness.

 As soon as you finish reading this paragraph, try this one out. Every time you get up to go to the restroom (or do some other activity that takes you from a regular location), pay attention. Look closely at everything you see and pass. Notice details that you would normally ignore as you walked by. It is not necessary to slow your pace or to try to memorize everything, but be very conscious about everything you see. When things are moved or different the next time, notice what has changed. Be focused on looking at things and people. Don't just let the things around

you flow into your eyes; make use of those eyes. Really use them to absorb everything there is to see. When you have mastered this (or feel you have) on your trips to the restroom, add the practice to other walks. Pretty soon you will do it all the time, and you will probably discover that while you may have seen most of the world, you've actually observed very little of it.

4. What are your physical gestures?
 Michael Chekhov spent time discussing physical gestures.[1, 2] What gesture best represents an overall character? What gesture best represents the character in each scene? Ask these questions of yourself. If there had to be one physical gesture that represented you, what would it be? Are you a fist slamming down? Are you a firm handshake? Are you applause? Are you a muscle pose? After you have spent the time necessary to come up with the gesture that you think most represents you, try it on. Spend a day or two thinking about being that gesture as you go through your regular activities. Does the gesture still seem to fit? If so, for each scene of your day-to-day life, board meetings or staff meetings or client meetings or business lunches, think about a gesture you would be for that meeting. It should be something that stems from your main gesture. If you are a muscle pose, then perhaps at board meetings you are a bicep curl. At staff meetings you might be fists clenched together and arms pulling apart. At client meetings you may be in a Superman pose. At business lunches you are Rodin's Thinker. Find the gestures that work best for you, and think about them.

5. What are the physical gestures of others?
 When you have found the gestures that best define you, and you feel comfortable thinking about those different gestures as you go through your day, start to guess at the psychological gestures of others. Of course, you will never know what their gestures really are. In all likelihood, unless they have read this book, they will not have thought of psychological gestures. But forming an opinion about what physical gesture might be the one they would think about gives you a sense of how you believe they perceive themselves. It also helps you to see the connection between thought and physical behavior, both in yourself and in those you interact with.

6. Practice listening.
 Pick ten minutes every day when you are meeting with a group or other individuals, and focus on listening to everything that can be heard. Make it essential for you not only to hear, but to comprehend every single word spoken. You may think that you are a good listener, but you will be amazed how much you actually do not listen to. Our minds drift constantly. Someone makes a comment that causes us to think of something similar, which causes us to think of something else. Staying focused on what people are saying is impossible. Practicing it can make us much better at it.

But people are not the only things going on. Someone clicks a pen. Someone ruffles some papers. There is a sigh. A foot scuffs along the ground. Listen intensely and intently for everything that can be heard. Those sounds tell us about what other people are doing, such as not listening to the person speaking. At first, you will find it impossible to listen to people and things at the same time. As you continue to practice, you will find that you can do both. When that happens, stretch from ten minutes to twenty. Eventually you will be listening to an awful lot of sounds. And all that input is data to a strong leader.

7. Focus energy.
One of the things actors do is focus energy. A typical exercise is to relax and then feel the energy in some specific part of the body. The brain focuses on where the energy is and what it feels like. The exercise allows the actor not only to have a sense of that part of the body, but to begin to understand its strength and power as a communication tool.[3] Chekhov taught his students to move this energy around the room. To take it from their body and to shift it around the room to others.[1] Take a few quiet moments each day to close your eyes, relax, and focus on one specific part of your body. Choose a different one each day: abdomen or left leg or the nose or anywhere else. Feel the energy focusing there. It will take a minute or two before you can feel it, but you will. Stay focused on the area. Once you have mastered this, force the energy to move from one part of your body to another, and feel it as it travels through your body. Finally, when you are comfortable feeling the energy move, try focusing your energy during meetings with others. Eventually, you will be able to pass it to them.

8. Work on your mission.
Finally, you always need to keep your eye on the prize. It doesn't matter how well you play the game. In the end, you need to achieve your goals no matter what line of business you are in. Some people have argued that the "journey is always more important than the destination." That is easy to say once you have reached your destination. Your goal as an effective leader is to accomplish your mission. There may be no "right or wrong" way to do that, but there have been others before you who have tried and failed. The trick is to do your best and to succeed. Take sixty seconds at the start of each workday to focus on the mission of today, the mission of the week, the mission of the month, and how they all belong to the company's mission, and involve the work of your subordinates. At the end of the day, take sixty seconds to consider whether you have accomplished or are accomplishing each mission.

Designing Work Groups

Perhaps one of the biggest challenges a leader faces is getting the right people together in the right place at the right time. Just as casting is 90 percent of a director's job, putting together the right work group is probably 90 percent of a leader's job. There is no perfect way to create a work group, but there are practice techniques that can help you develop skills to do the job.

1. Cast correctly.
 Just because you know your staff, and you think you know how well they will work together, does not mean that you truly do. There is no guarantee that you can match the right people to the right work groups; making the right hiring decisions is the first key in the process. Let human resources match resumes to job descriptions. You should be matching people to people. If you have begun to get a sense of the masks your staff members wear, or the psychological gestures they would be, you should know what you are looking for. People with gestures that are complimentary, and whose masks and styles of interactions are complimentary, work well together.

 Do not simply cast the superficial. A person who tells a lot of jokes and a person with a great sense of humor may not match. If the joke teller likes to debate with anecdotes, and the one with a sense of humor likes to debate with facts, the two will have a difficult time reaching consensus. Cast because people are good together, not because they feel good together. Develop different "casts" in your head of what a work group might be like. Give each cast member a different role. Try them in different combinations. Eventually you will see the right fit, even if it means casting some against type. And remember, casting means giving each member of the team a role, and not just making them all team members.

2. Involve the audience.
 When you are developing a work group, ask yourself, how will the group and its work product interact with the outside world? Find members of the outside world and, at the least, get their opinions on your casting. In a perfect world, you would include them in the work group. This may not be feasible. Instead, set up regular meetings with the work group and the outside world. And challenge the group and the world to challenge each other.

3. Hire a stage manager.
 In the work group, assign one person to be the center of communication. They record discussion and ideas. They track meetings. They keep notes of interactions and of decisions. They make reports of daily activities, make requests for more resources when required by the group, and speak on behalf of the group. The stage manager is not only a central

source of communication, but a buffer between interference and anarchy. It is not the function of the stage manager to be part of the work group process. They are the central hub. They can also be your source of information. Cast someone as stage manager that you trust to do excellent work.

4. Transfer authority.
 Even if you are part of the work group, transfer authority around. Do not make a rule about how it is transferred—let the group determine its own work rules—but let them know that you would like them to transfer control of the group, the formal authority, amongst all members at various times. Shifting formal authority frees certain members of the group, it empowers others, it changes the dynamic, it allows information to flow more erratically and naturally, and it helps to prevent more vocal members from domineering. When the group asks you for guidance on how to do something, advise them to consult their current authority.

Develop and Address Problems

One of the biggest challenges within a work group is that the actual problem is not defined clearly enough to develop solutions.[4] But deeper than this, once the actual problem is defined, a number of hidden issues usually lie below the surface, interfering with the problem-solving process.[5] Ensuring a successful collaboration with a work group means taking the important first steps in the right direction.

1. Do warm-ups at meetings.
 Before each rehearsal and performance, actors warm up. They stretch their muscles to ensure they are physically prepared. They vocalize certain sounds and move their lips and tongues to ensure that they are able to use their tools to the greatest advantage. Some meditate to relax their minds. Actors' Equity Association requires that dressing rooms be quiet for actors to prepare. Team meetings should begin with warm-ups as well. Think of some new and different things that teams can do to warm up, and try something different each day. You could have people tell a secret about themselves that no one else in the group knows. You could have them share their favorite food, flower, and state and explain why. You could play musical chairs. You could draw names to see who will come up with the next meeting warm-up. But be sure that before each meeting, you do something to warm up.

2. Help people "find" what they are good at.
 Helping people find what they are good at, and encouraging them to focus on strengths, is a key to good leadership of creative people. Sometimes it means calling people into your office, or even better, stepping into theirs, and asking what it is they enjoy doing the most. People

usually enjoy what they are good at, and they are good at what they enjoy. If you spot strengths, encourage them. Cast people in ways that will stretch their strengths to new levels.

3. Find the real problem.
Consensus begins by defining the problem. Even if your group has a very specific charge for creating something, set that charge aside. Pull out the easel and paper and begin to brainstorm. What is the problem, exactly? Make certain that the final product of this brainstorming is a statement that clearly and succinctly defines the problem. It may require bullet points to help clarify, but without a clear problem, a clear solution will be elusive. When all have agreed on a problem, the group will know both what consensus feels like and how to reach it, but they will also be well on their way to achieving it in the solution. The problem statement becomes, in effect, the mission of the work group. Leave it on the wall and refer to it often.

4. Find the hidden issues.
Finding hidden issues is far more difficult than it sounds. The real trick is to be able to stop the group from working on solution-finding long enough to discuss what appears to be slowing progress. This means that you must again trust your instinct. If someone is repeatedly interrupting, there may be a deeper reason why. Simply saying, "Don't interrupt," won't eliminate the obstacle toward consensus. Instead, watch for who is being interrupted. Look for patterns. Eventually, be willing to step forward and say, "We seem to have a challenge and I would like to discuss it." You may have to bring this page with you and share it with everyone, because people often object to discussing the hidden issues, but without getting them on the table, the real work can never occur.

Fixing Work Groups

There is never truly Nirvana or Shangri-La. Business is always filled with flaws and obstacles, challenges and changes. Fifty percent of the SWOT analysis looks at weaknesses and threats. Business is never perfect and it is rarely easy. In theater it is called *play*, but in business it is called *work*. The leader, especially of those with creative challenges, can control much of how the organization runs. This does not mean that every organization must be a playful environment. But it does mean that the choices a leader makes, whether they lead a team, a division, or the whole company, have a profound impact on those being led. Because we are all, as both team members and human beings, works in progress, there is always work to be done to fix a work group. There are some exercises that can help make better work groups.

1. Make the worst the best.

 A trusting leader is someone who is able to help people through work challenges. There is so much that goes into how we determine which people get what sort of support and which people get others. Focusing negative energy on low performers is certain to lower their performance. Praising high performers leads to increased workload being placed on them. To succeed at being a trusting leader, identify the weakest link on your team, whoever it may be, and for whatever reasons you believe they are the weakest link, and let them know that you are going to help them to become the strongest member of the team. Plan regular meetings, identify trouble spots, and find ways to solve or work around them. Build on strengths. Mentor them constantly, regardless of whether you like them or not (you soon will). When that person has become the strongest team member—and with your guidance it should not take long—find the new weakest team member and do the same. The process never ends, but you will be both trusted and trusting.

2. Take care of fragile egos.

 Fragile egos are difficult to lead, because they want to be free. Spend a few minutes in every meeting looking for unique, different, odd, even downright weird ideas. Praise the creativity that goes into those ideas. People put out creative ideas all the time, and often we move on without acknowledging where the thoughts came from. Creativity must be nurtured. Even if the idea is not workable, request more ideas like it, and try to build off each one. A second part to this exercise is to have a moment at every meeting where people share some creative thing they were a part of recently. It can be related to work, or not. This is noncompetitive. It is just a sharing of creative things to get the juices flowing. It encourages egos and creativity.

3. Keep pressure on.

 Ensuring that there is a sense of urgency to what must be done is important.[6, 7] It creates a level of pressure that is essential for the cooking to happen (remember the pressure cooker?). But the pressure cannot be too much either. The leader is the person who maintains the pressure by striving to achieve the best out of everyone, but relieves it if it becomes too intense. Under the problem statement, jointly develop a timeline. Ask your group: why does this have to be done and why by this time? Make the timeline a bit of a stretch goal. For complex tasks it may be longer. For easy tasks it may be shorter. But in any case, make sure that it is achievable, but difficult. You can always extend it later. When things get off track or too relaxed, use the timeline as your thermostat. Turn up the heat.

4. Do "yeah, yeahs" during rehearsal; take notes after.

 During the creative process, be like Everett Galveston in a rehearsal. When you hear or see things you like, shout out, "Yeah, yeah" as often as you can. Encourage the team and push for fast-paced, creative activity.

It will not only make people feel good, it will give them a sense of safety. The creative effort is not a place where they will be criticized or evaluated. At a later date, maybe once a week, give them notes. These are not criticisms, but ways of making even better what they are already doing. By separating the creative activity from the notes, you leave the creative environment safe.

5. Practice the work of the group.

 When the group has worked out details and found some sort of wall that they cannot get past, practice what got them there. Repeat it. Have the same discussion, or as close to it as possible. Look for the spot where the path headed toward the wall and try to veer away. If you aren't finding the answer, repeat it again. Repetition is the key to greatly improving something creative. Do not be afraid to repeat exactly what your group has done before. Think of it as rehearsal.

6. Say yes and say no.

 Respected leaders say yes even when they are not certain the thing they are saying yes to is the best course of action. They say it because they trust the passion, the energy, the drive, and the creativity of the person making the request. Every day, find a way to say yes to someone, especially when it is something you might question. But respect is also earned by saying a hard no once in a while.[8] This is the "no" that you do not wish to say, or that may make you look mean in someone else's eyes. Make them wisely, not randomly, but once a week, when you have to, tell someone, "I have heard what you have to say, and I think it is well thought out, but given all the other information I have, I am saying no."

1. Chekhov, M., *To the Actor: On the Technique of Acting*. [1st ed.] 1953, New York,: Harper.
2. Chekhov, M., C. Leonard, and N.V. Gogol, *Michael Chekhov's To the Director and Playwright*. 1st Limelight ed. 1984, New York: Limelight Editions.
3. McVittie, F., *Top-down and bottom-up approaches to actor training*. Journal of Visual Art Practice, 2007. **6**(2): p. 155-163.
4. Beyerlein, M.M., *Beyond Teams: Building the Collaborative Organization*. The collaborative work systems series. 2003, San Francisco: Jossey-Bass/Pfeiffer.
5. Heifetz, R.A., *Leadership without easy answers*. 1994, Cambridge, Mass.: Belknap Press of Harvard University Press.
6. Kotter, J., *Shared urgency*. Leadership Excellence, 2008. **25**(9): p. 3.
7. Kotter, J.P., *A Sense of Urgency*. 2008, Boston, Mass.: Harvard Business Press.
8. Heifetz, R.A., A. Grashow, and M. Linsky, *The Practice of Adaptive Leadership: Tools and Tactics for Changing Your Organization and the World*. 2009, Boston, Mass.: Harvard Business Press.

Chapter 11
What it All Means

"Don't fear failure so much that you refuse to try new things. The saddest summary of a life contains three descriptions: could have, might have, and should have."

– Louis E. Boone

"It is the supreme art of the teacher to awaken joy in creative expression and knowledge."

– Albert Einstein

"True knowledge exists in knowing that you know nothing."

– Socrates

One of the reasons that all those airport books exist is that we are always trying to make ourselves more knowledgeable. In business, we want the competitive edge. We want to be able to achieve more than the guy below us, or next to us, or even above us on the corporate ladder. You have gotten to the final chapter of this book because you are interested in trying something fairly unique and different, but something that makes perfect sense. Creative people do not work in cubicles with their heads down like so many of their corporate ancestors did. Business is now about teams, and social

interactions that develop business decisions. You want to be successful and have the edge. You do not want to be the guy who could have been CEO if only he had figured out how to work with *those* people.

If any of that describes you, then the exercises in chapter 10 are probably something you are willing to try. You are a person who seeks a bit of adventure and is not afraid to try new things. Even if those exercises seem silly to you, or way too "granola," give them a try anyway. If you practice them for a reasonable amount of time and you gain no reward (which is extremely unlikely) then abandon them and go back to doing what you were doing. You will have tried something and failed. That is not the end of the world. But if you are the adventurous type, then try them, practice them as hard as you would in the real game, and be a winner. Always remember, the definition of insanity is doing the same old thing but expecting a different result. Some things work while others do not.

There are so many different aspects to effective leadership, and if we could manage to know all of them, we would never be able to balance them all. The theories and subsequent exercises in this book are designed to help you focus on the various aspects of leadership, especially as they relate to those people who do creative work.

Keep in mind the types of leaders that can be most effective with creative people as you go about your work life.

1. Instrumental leaders have clear expectations and they provide resources for people to achieve those expectations.
2. Charismatic leaders have charm, style, and panache that cause followers to engage.
3. Personable leaders genuinely care about people and show true concern for the work and the workers.
4. Inspirational leaders mentor followers and provide a strong role model for emulation.
5. Trusting leaders are both trusted by followers, and trust their followers.
6. Communicative leaders ensure a transparent flow of information to and from followers.
7. Consensus leaders work to bring people together to engage in ideas, and help them reach a shared decision.
8. Collaborative leaders work almost as a member of the team, rather than as the formal authority. They allow informal authority to have greater control.

To simply *become* any one of these would be impossible, even with an instruction sheet of what to do. Each one requires the development of certain personality traits and behaviors. The exercises in chapter 10 are designed to capitalize on the key traits and behaviors that can be found in all eight of these leaders of the creative mind. Engaging in the exercises as if they are essential to success will develop in you not one, but eight leadership styles that you will demonstrate on a daily basis.

One important thing to keep in mind. The exercises are not designed to be done for a while and then stopped. Like the scales and arpeggios of a concert pianist, or the layups of the basketball star, you must work at them constantly and never stop. They are designed for repetition. Because even when leading the creative mind, it is practice that makes perfect.

CPSIA information can be obtained
at www.ICGtesting.com
Printed in the USA
BVHW042344020222
627738BV00003B/103